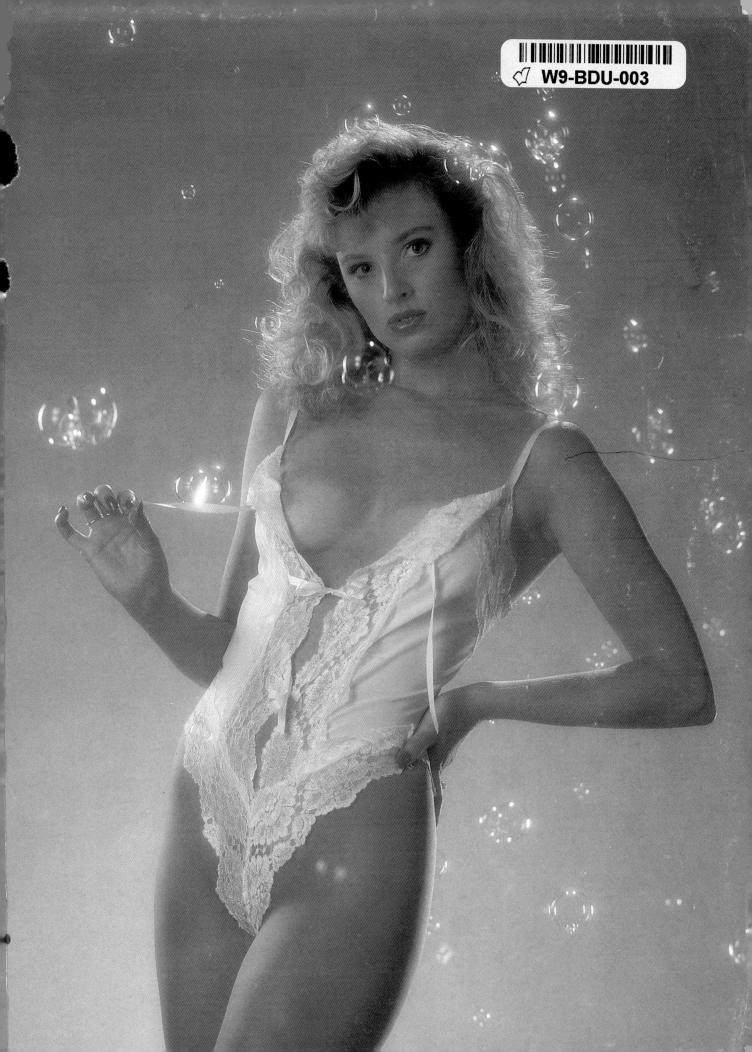

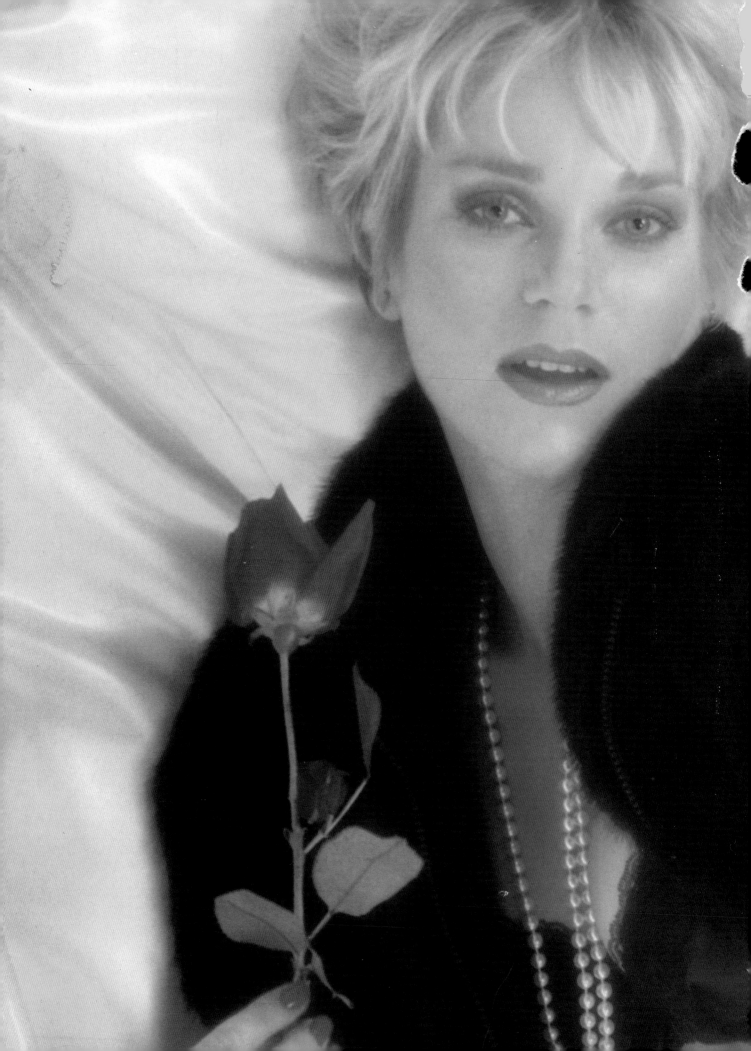

Boudoir Studio

Professional Techniques for Glamour Photography

Roxanne Becker-Wortham
and Robert Wortham

AMPHOTO
An Imprint of Watson-Guptill Publications/New York

Acknowledgments

There are several fine people we wish to thank for their assistance in producing this book. First, we want to thank Glorya Hale, Marisa Bulzone, and Susan Hall at AMPHOTO. Without their support of and belief in our work, this book would not have been possible.

Very special thanks to Jon Coduto, Bridget Malley, and Bob Gibson at Hollywood Central Props in Glendale, California. Thank you, too, to Diane Samandi at Jonquil Lingerie in Santa Monica, California, for supplying us with some of the most beautiful lingerie we have ever seen. Our deep appreciation for their work goes to stylist Cristina La Bianca and makeup artists/hair stylists Karen Knopp and Ali Greene at Entourage. Special thanks also go to Ali Greene for talking us, step-by-step, through the section on makeup. Our tasks would have been extremely difficult without all of your artistic talents. Thank you to Lesa Garduno and Nick Koon, our faithful studio staff, and the people at Color House Color Lab.

Last of all, special thanks to the willing clients and women who really are the stars of this book.

Copyright © 1989 by Roxanne Becker-Wortham and Robert Wortham

First published 1989 in New York by AMPHOTO, an imprint of Watson-Guptill Publications, a division of Billboard Publications, Inc., 1515 Broadway, New York, NY 10036

Library of Congress Cataloging-in-Publication Data

Wortham, Robert.
 Boudoir studio.

 Includes index.
 1. Glamour photography. 2. Photography of women. 3. Photography—Portraits. I. Becker-Wortham, Roxanne. II. Title.
TR678.W65 1989 778.9′24 88-33342
ISBN 0-8174-3565-4
ISBN 0-8174-3566-2 (pbk.)

Manufactured in Malaysia

7 8 9 / 97 96 95 94

THIS BOOK
IS DEDICATED
TO THE BEAUTY
THAT LIES WITHIN
ALL WOMEN.

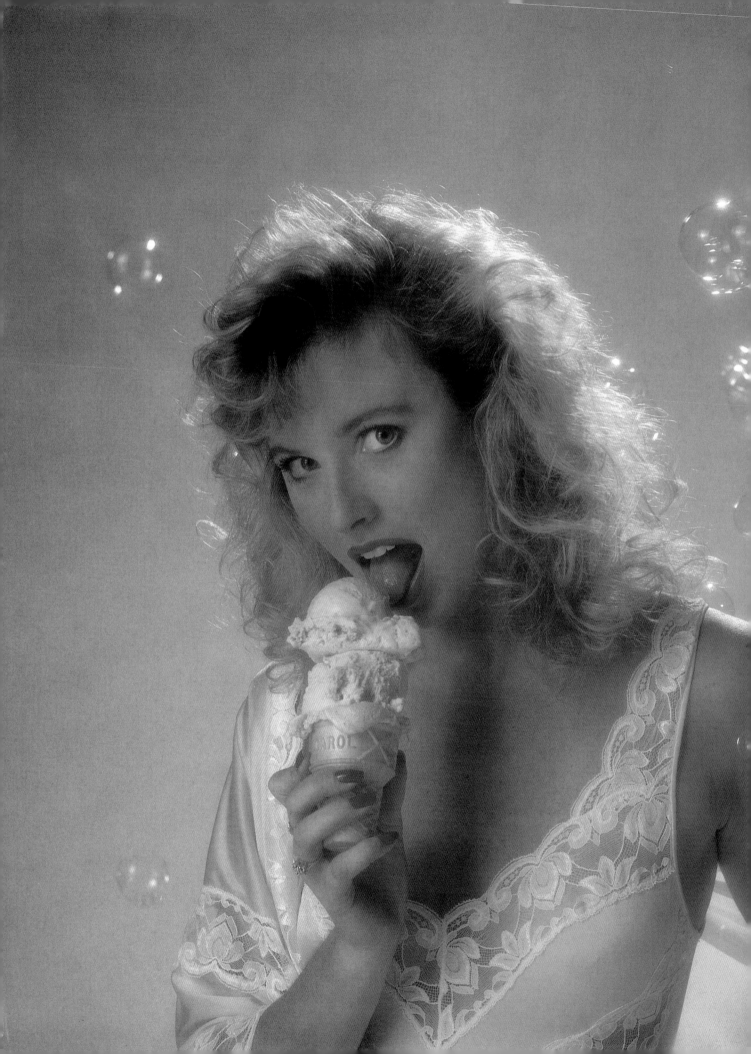

Contents

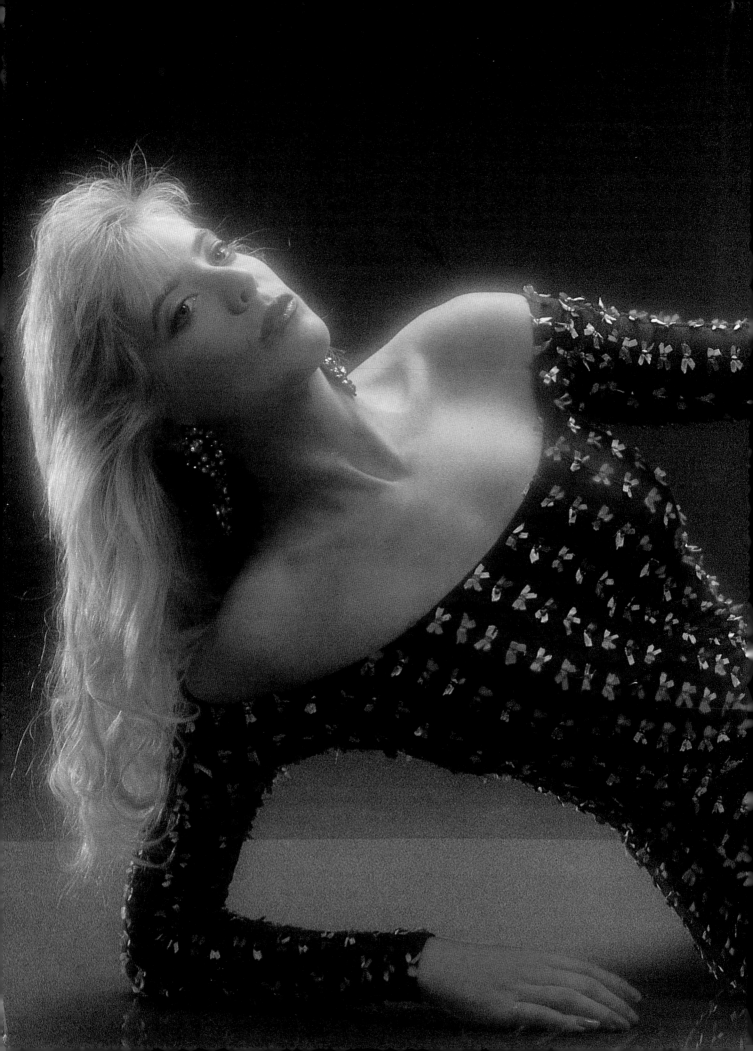

PART ONE

Getting Started

WEBSTER'S DICTIONARY defines the word *boudoir* as meaning a woman's private room. So it is that *boudoir photography* has come to be the term for sexy photography of a woman wearing lingerie. When boudoir photography first received public attention in the early 1980s, the primary focus was placed on women wearing lingerie in a bedroom set or similar environment. We felt, though, that the real emphasis should have been placed on the fact that women were seeking out photographers to capture the *sexy* side of themselves for their loved ones. From the onset of the boudoir trend, our studio has expanded the definition of boudoir photography to include unusual sets and styling.

Since our clients always ask us for new and different sets to work with, we now shoot boudoir-mood photos in such environments as our jungle set, for example. Whether we are shooting a client in a bedroom or jungle, our definition of a boudoir photograph still applies: it is a private portrait being commissioned by a client to reveal a sensual side of herself. This search for and creation of new sets all of the time keep our interest and level of involvement high in our business.

We feel that the purpose of boudoir photography is to capture a woman during *any* private pensive moment, so, in our studio, boudoir photography is more than just "bedroom" shots. Our work differs greatly from traditional "glamour" photography, where the photographer is usually trying to capture a woman's beauty for the eye and taste of a man. With boudoir photography, a woman is showing what *she* feels is attractive about herself, and sharing her sensuality with her partner. *She* gives the photographer the premise and direction for the shoot.

As boudoir photographers, one of our greatest feelings of satisfaction comes from the fact that our imaginations can run wild. This is wonderful for the two of us, because when we work as commercial photographers we are constantly asked to shoot within the confines of a layout. In our boudoir business, though, we begin with a rough idea of what we want, until all of the elements of a session come together, we are able to work on a freer basis.

Creating an air of sensuality on a set is important. In this photograph, the position of the model's arms and the intensity of her gaze reveal her allure, and the mirror adds an elegant touch.

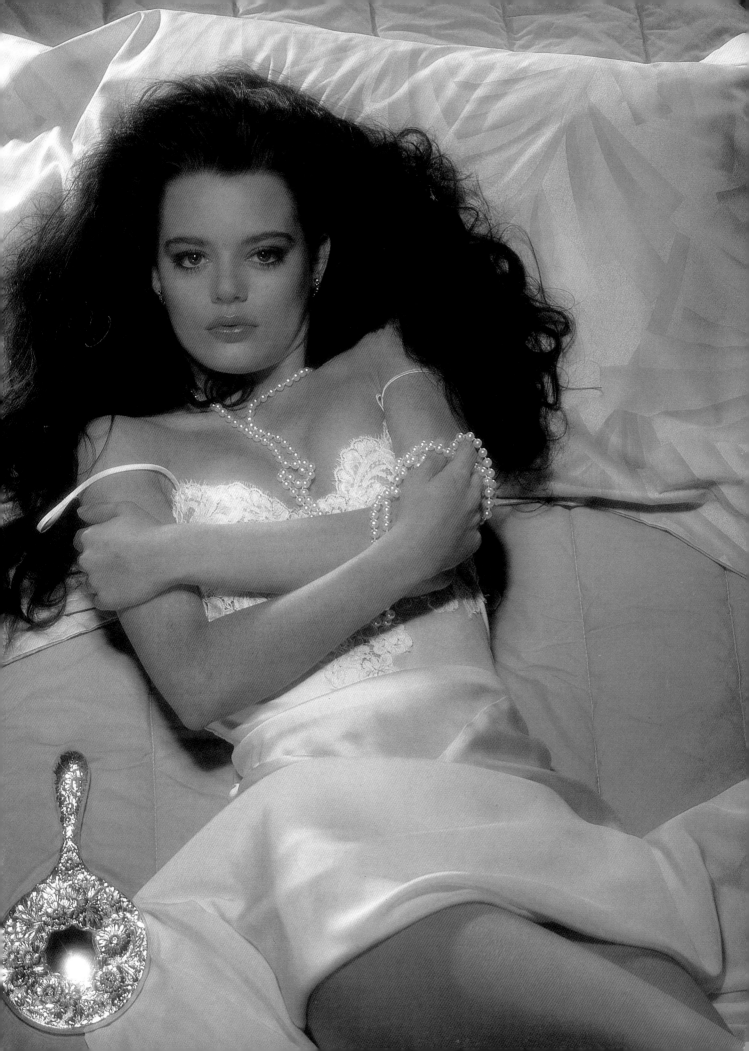

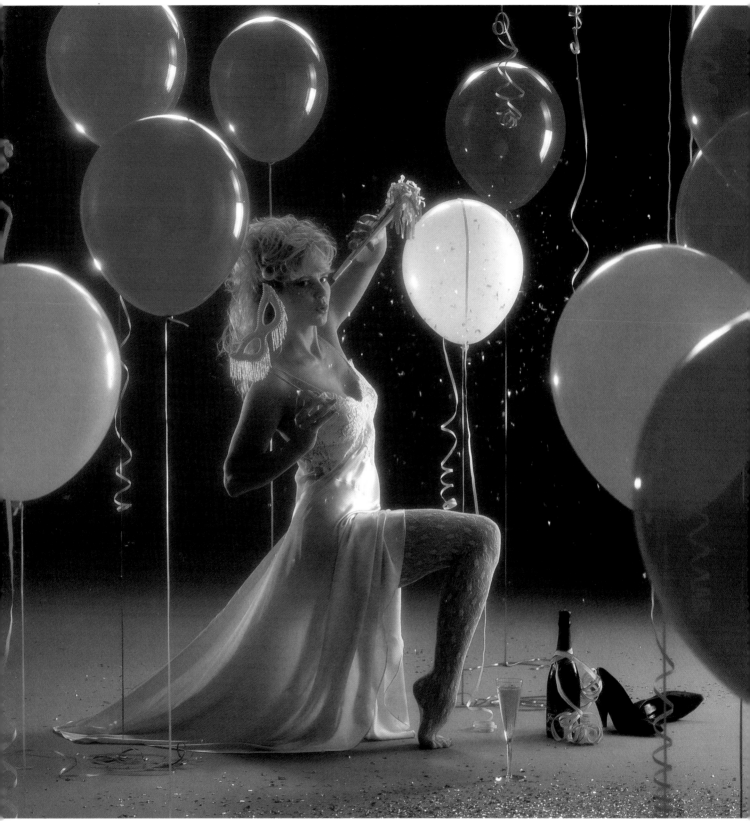

*The festive nature of a holiday
set can inspire a client to be
exuberant in front of the camera.*

Another of our great satisfactions comes from showing ordinary women that they, too, can resemble the models they see in magazines. The public is constantly surrounded by sophisticated media that transforms regular individuals into "perfect" human beings, yet many people are unaware that lighting and other techniques are used to create these illusions. Boudoir photography is helping to change women's perceptions of themselves in comparison with the super models they see in magazines. Many women realize a new inner sense of confidence after a boudoir session. The combination of their new understanding of the process involved in a commercial shoot, along with the feeling that they, too, can be model-glamorous, seems to work magic for them. After dealing with several of these happy clients, you, too, will feel as pleased as they.

The degree of nudity in any boudoir photography session is left up to our clients. We do not push them, nor do we hinder them. Many photographers ask us to what extent boudoir photography crosses over into nude photography, and we say that, as long as it is a commissioned portrait done for private purpose, it falls into the realm of boudoir photography, and whether or not it involves nudity is immaterial. We are shooting a portrait of a woman, for herself, and personal judgement and taste are left to both photographer and client. We might note that we are successful because we offer our clients the utmost in taste and sensitivity in fulfilling their desires.

There are as many reasons for doing a boudoir session as there are women to photograph. Although our client profile varies, most of our clients are middle- to upper-class women, and most are career-oriented and well-educated. Some of their reasons range from wanting to give a wedding gift to a new husband to creating a gift for a partner in a thirty-year marriage! Some women just feel good about themselves and want to do it for that reason. With the fitness movement that has occurred over the past decade, there has been a new consciousness about healthy, attractive bodies, and it's not only the young who have jumped on the boudoir bandwagon. We have photographed many clients who are grandmothers. Remember that all women have wonderful qualities and attributes. It is your job to uncover those qualities in a skillful

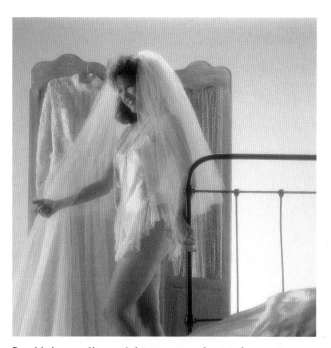

Combining reality and fantasy can also produce memorable images. Pictures like this make an ideal—and most welcome—present for any bridegroom.

During the photo session, we work with the model to achieve the effect she wants. Most clients respond by revealing their sensual sides. The resulting images, like the shot above, are striking.

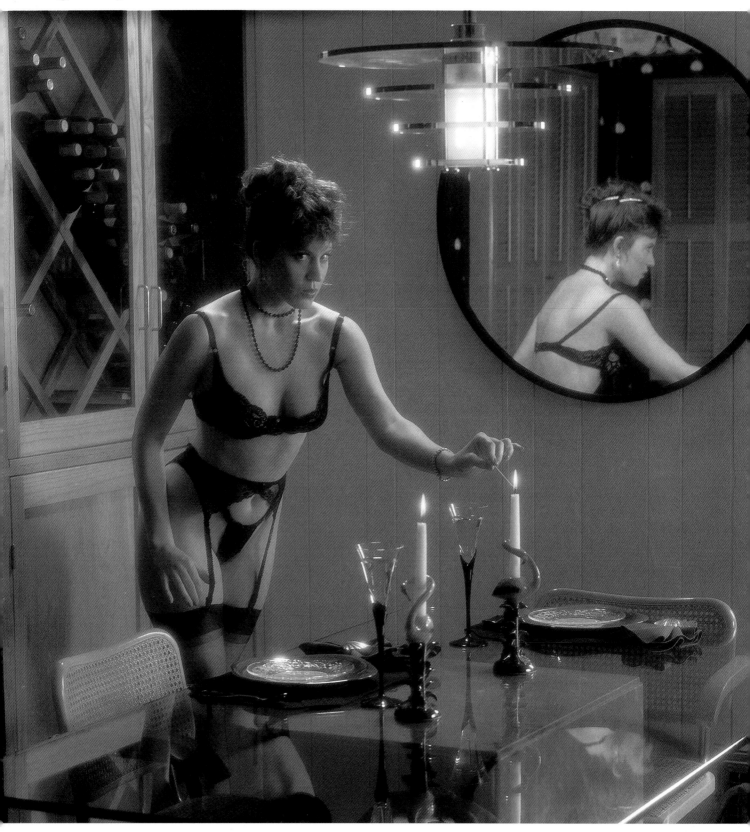

*This client's lovely Art Deco dining room provided the
ideal setting for this fresh approach to boudoir portraiture.
The model's lacy black lingerie worked perfectly here,
making her—and her dinner invitation—irresistible.*

manner that pleases your client.

It has been our experience that sometimes clients come to us with either deep-rooted fantasies of themselves as models, or feelings of inadequacy resulting from the pressure on women to be beautiful within our society. It is important to understand a client's motive, so that you can realize your limitations, if any.

For example, we have had extremely overweight clients come to our studio expecting to photograph—miraculously—much thinner than they are. You must be careful when promising clients such "dramatic" results. Though your end results may indeed be dramatic, be realistic and gentle when confronting unrealistic requests from your clientele. Keep in mind that you are working with many nonprofessional models who will be looking to you for guidance. Educate yourself as much as possible in the fields of wardrobe, color and sizing, posing, the most flattering body positions, lighting, makeup, hair, and so on, to make them as comfortable as possible.

There are many levels of expertise to be found in the field of boudoir photography: wedding photographers who add boudoir photography to their repertoire, glamour photographers who offer their talents to the general public, and photographers who specifically enter this business right out of school. Certain photographers do nothing but location work, while others exclusively work in a studio environment.

We feel male/female partners make up the best boudoir team, so if you are considering running a boudoir business, it might be helpful to have a partner of the opposite sex. This combination allows for total comfort on the part of your inexperienced clientele.

Our business started out as a commercial product studio and has grown to include boudoir photography for many reasons, including the fact that we have come to enjoy working with models after many years of working with inanimate objects. We bring to the boudoir business many years of lighting and design expertise, making us a very popular boudoir studio, because we are able to do such a beautiful job with our clients.

It is important to note that the fresher and more contemporary your look and techniques are, the more work you will receive.

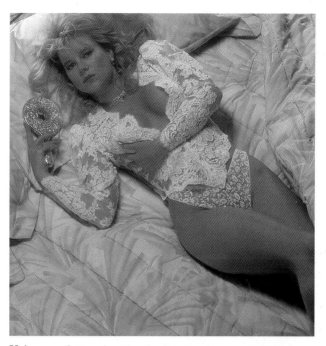

Using comforters is a lovely, inexpensive way to change backgrounds and add color and texture to any studio shot. You can combine a comforter with other bed linens, pillows, props, and outfits to achieve a variety of different looks. Here, the pastel shades of the comforter provide the perfect background for the model's delicate, lacy lingerie. Having a model wear a romantic, old-fashioned dress for a shoot, as in the bottom photograph, results in an intriguing combination of innocence and sensuality.

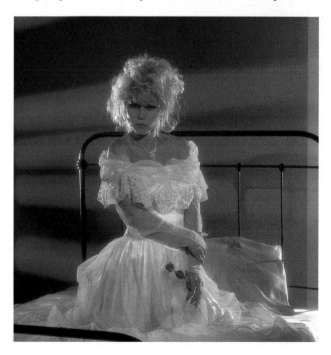

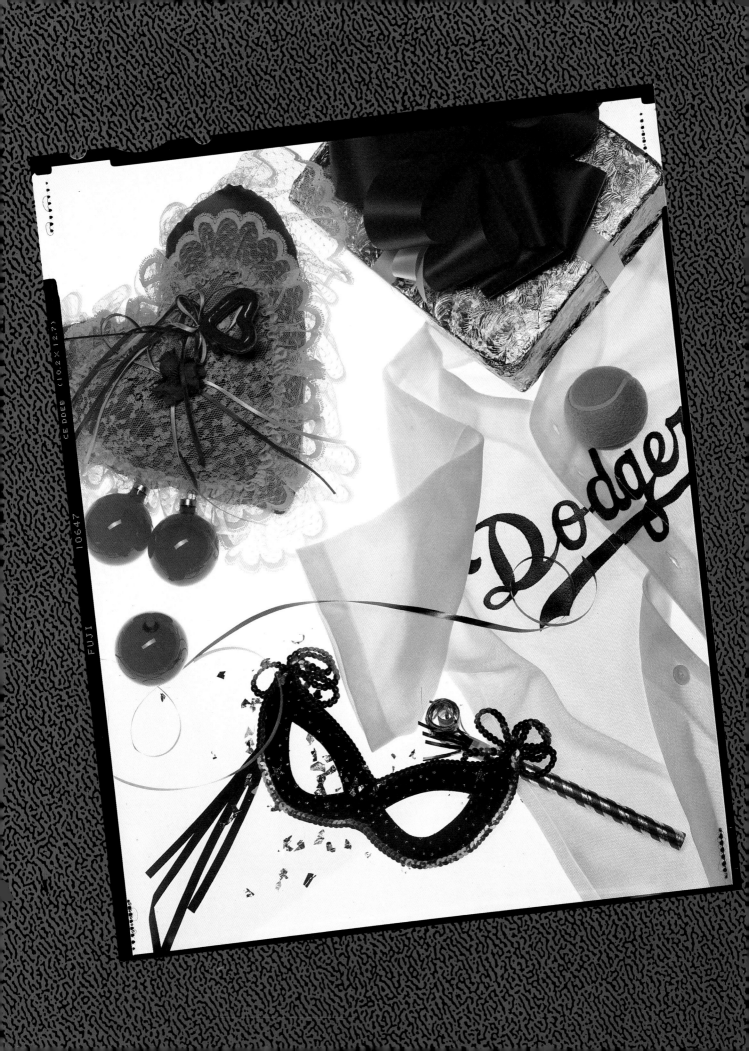

A Step-by-Step Approach to Boudoir

It takes a lot of work to master all the ingredients that make a successful boudoir session. From the technical side of photography to the sets, makeup, wardrobe, and posing, there are many details to consider. Building a good boudoir business takes practice and hard work. We hope this book will contribute to the way *you* approach boudoir. If you learn just onc new technique or trick, then we'll have been successful. Every photographer has his or her own unique way to solve a photographic challenge. What follows is our own particular approach to boudoir photography—a view that works for us. We encourage you to use these techniques in *any* manner that works for you!

Each session of ours begins with a discussion of specific themes or sets that we consider offering to a potential customer. After brainstorming such themes and ideas, we suggest you poll clients, friends, and family before actually building a particular environment. This allows a photographer a chance for impartial feedback before investing time and money in a set. New techniques include contemporary styles of lighting. Using old classic techniques in portraiture lighting serve only to make your work appear outdated. Be mindful of contemporary trends in lighting, such as the current trend in photographing women using soft, dappled lighting, which can give the realistic feeling of natural light streaming into a room after being filtered through a tree, for instance. We often turn to fashion magazines in order to keep up with these latest trends in lighting, fashion, and color.

We also stress the importance of perfecting your shooting technique. As an example, treating a boudoir client as if her session is for a high school portrait is a mistake, and yet we notice many photographers shooting boudoir portraits in this manner, with the only difference being the subject's wardrobe! As a boudoir photographer, you must know how to elicit a sensual look, as well as a playful look by calmly talking your subject through her session. As with anything else, practicing makes perfect technique.

An idea for a new set can come from many sources, even a possible suggestion from a client. This is one area that we really enjoy: the brainstorming and discussion before a set is even created. We receive inspiration by observing current trends, hobbies, and special interests in today's society. For example, the movie *Raiders of the Lost Ark* inspired us to do a jungle/tropical set. Once we have designed and produced a new set and it is ready for a photo session, it is added to our selection book showing the variety of stock sets available for our potential clients.

During a consultation with a potential client, we discuss her particular photo session. The reasons for the session, who the session is for, and what feelings the client would like to portray during her photo session are all important considerations. As we guide her through the set selection process, we counsel her on wardrobe, makeup, and props. At the conclusion of this consultation we give our client a list describing how she will need to prepare for the session.

When the day of the session arrives, we have already assembled our set and props. A professional makeup and hair stylist is booked. Our styl-

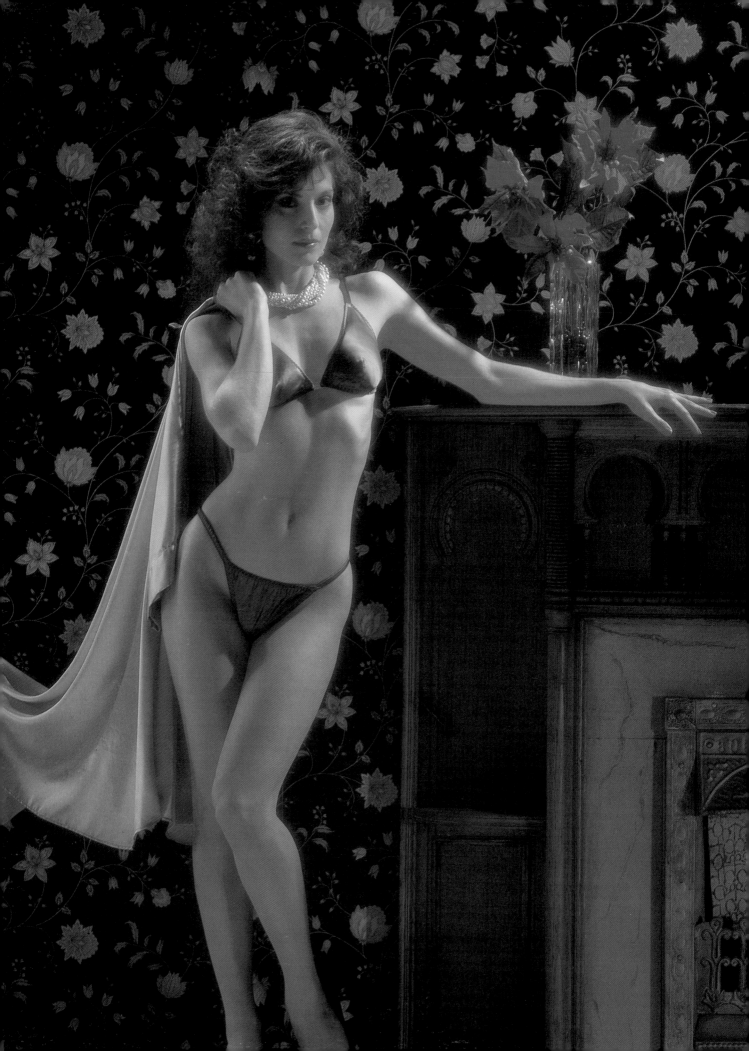

ist arrives before our client, to enable us enough time to discuss the requirements of the day's shoot. One of the jobs of our stylist is to help improve a client's confidence level. We work hard to set our clients at ease before their sessions. We cordially greet our clients to compose them from the start; then we sit down with them to review our photographic goals. What look are we trying to capture? What particular wardrobe will be involved? After a brief review and introduction to our stylist, one of whose main jobs is to raise a client's confidence level, we offer refreshments. Sometimes a few sips of champagne or a warm cup of tea will help a client relax, and sometimes chocolates or other tempting goodies are welcome. If the session is due to last more than a couple of hours, we often provide salads, fruit, or some sort of luncheon. Music is another tool we use to calm a client, after asking her what type she enjoys.

Our dressing room has a professional mirror and lighting system, with a large mirror and bright, yet flattering, lights in the makeup environment. A clean, comfortable dressing area is a nice touch, supplied with clean, comfortable bathrobes for clients who forget to bring their own. The key to calming a nervous client begins with anticipating her needs and desires.

While the client is undergoing her transformation with makeup and hair, we have finalized our initial camera position and lighting and are ready to take our first Polaroids to check how the set will look on film. The next step involves posing the client within the set. We discuss a variety of poses and then we place our model in her first pose. Our subject is shown a final Polaroid before film is shot, to make sure she is confident and pleased with the direction her session is going. This involves her in the session, and makes it more likely she will be pleased with the results.

A 5 × 5 print proof book will be the final result of a session, with mistake shots edited out. Our client will review her film while sitting in our conference room, which is adorned with a host of boudoir enlargements hung on the walls. The enlargements give a customer an idea of how her work will ultimately look. We will have samples available of all the enlargement sizes we offer, which include 30 × 40 blow-ups. While many photographers enjoy shooting transparencies that they

Before the session, we meet with clients to discuss wardrobe, makeup, sets, and props. This model wanted a dramatic, sophisticated look. Her pose and facial expression worked perfectly with the draped robe, the "marble" fireplace, and the rich wallpaper to create the exact effect she desired.

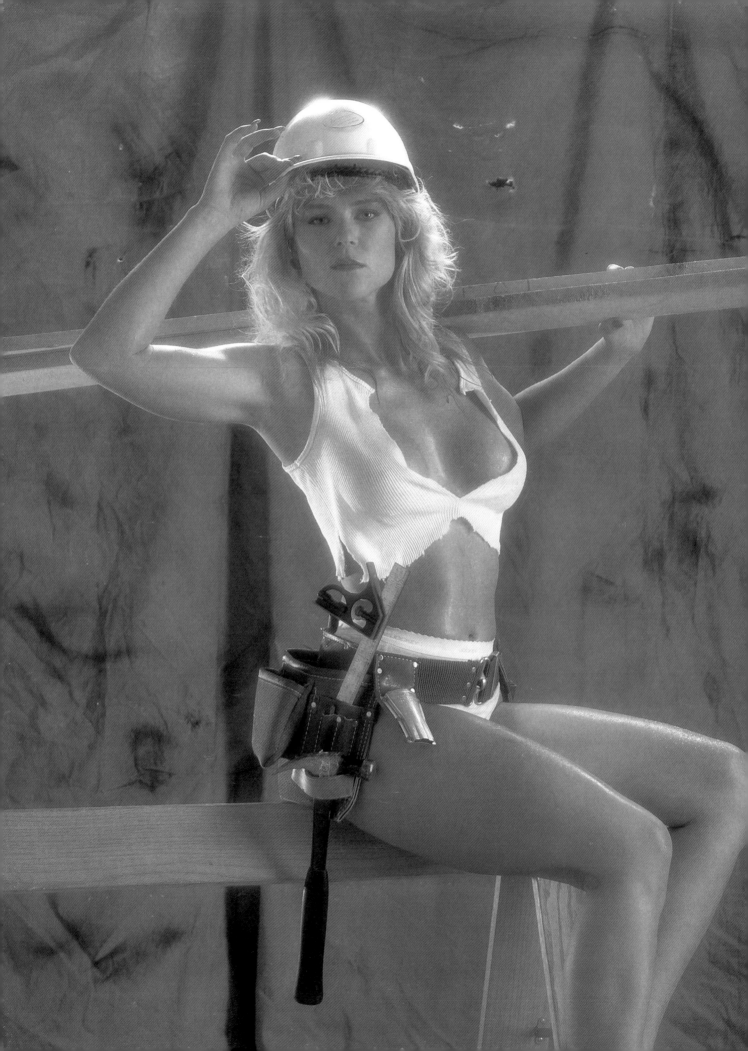

later project onto a screen for their models, we prefer shooting color negative film for our particular clients. We find that Cibachrome prints derived from transparency film can become too contrasty for boudoir photography. Color negative film can be better controlled, and it avoids creating another generation of inner negative. We enjoy working with the 5 × 5 proof books, and suggest you feel free to offer *both* methods, if you like. It's in the presentation of work to client that your efforts will be financially rewarded. A professional presentation, no matter what format is used, is essential to increasing your sales. Be imaginative, but be professional.

After our clients have made their selections and have ordered their enlargements, we typically arrange payment to consist of 30 to 50 percent of the money in advance, depending on the size of their order. The remainder is due and payable upon presentation of the final prints. On rare occasions we bill a client over a 15-day term.

We cannot stress enough to photographers how important their business skills are when operating their studios. You must set up a policy that works for you, and you must stick to it! We strongly recommend reading the guidelines specified by the *ASMP* (American Society of Magazine Photographers) or the *APA* (Advertising Photographers Association) guidelines. If you are considering going into boudoir photography or expanding your business to include boudoir, please consider our advice. First find out the current going rate for boudoir photography in your area; then position yourself accordingly, to what your studio can offer. We caution photographers who cut the bottom out of their prices, as they will end up working long and hard for little or no profit.

Because of our extensive commercial background and facility, our studio is one of the most expensive boudoir experiences in our area—perhaps two or three times more expensive. Nevertheless, we are popular. People will pay for quality and value, so strive to be the best; it will come back to you as it has come back to us. After many years, our business is now almost exclusively at the word-of-mouth level. Boudoir photography has not only been rewarding emotionally, it has been rewarding financially, which should be encouraging to you.

Using a few important props, we created a simple but effective picture of a client as a construction worker. Innovation and creativity will produce boudoir photography that is appreciated—and sought after—by clients.

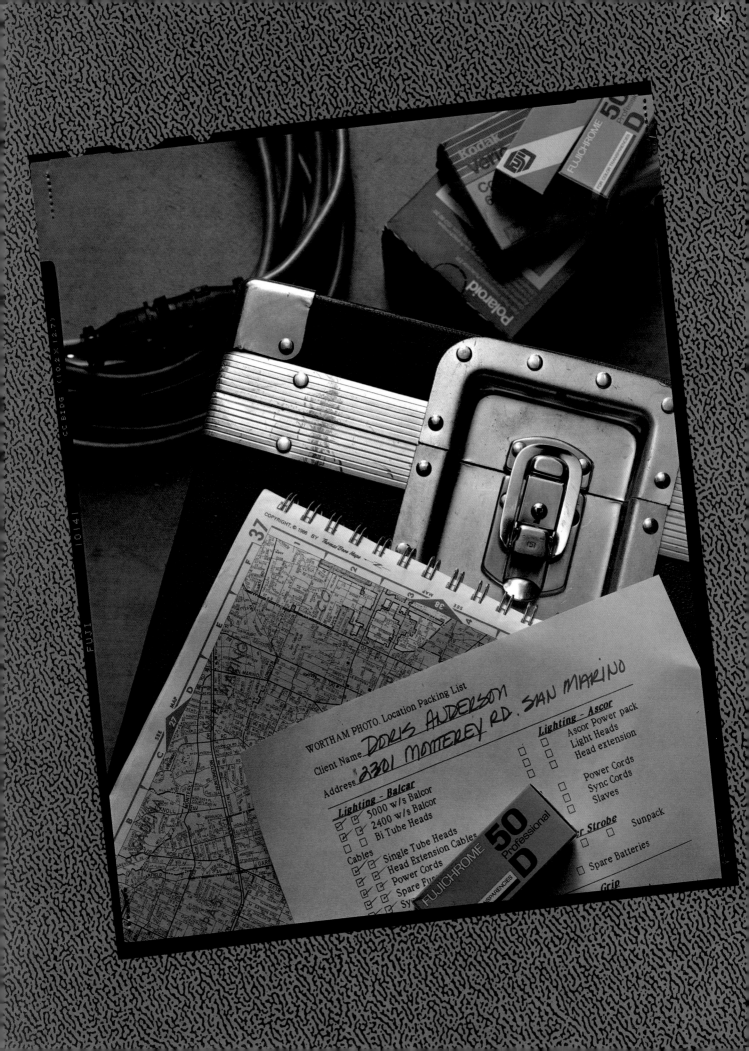

Photographic Equipment

We keep telling ourselves that we were not lured into photography by great gadgets and gizmos, but over the years our equipment storage rooms have gotten continually larger and more crowded. However, wonderful pictures are shot with the most rudimentary lighting, while sometimes nothing better than snapshots come from people whose equipment rooms look like the annex to a major Hollywood camera store. Equipment is important, but not nearly as important as learning how to take best advantage of the gear you have. The only way to greatness is to push yourself into not settling for anything less than what is in your mind's eye.

THE IMPORTANCE OF SHOOTING POLAROIDS

We cannot say enough about the insurance that exposing Polaroids before recording the final shot on film can offer a photographer. Polaroids not only show photographers technical equipment problems that can arise, but also allow them to show clients an essence of what her session will look like—an instant gauge. Because of the nature of the photo session, you will find the women you work with highly sensitive to how their figures photograph. We do not show our clients preliminary Polaroids, only final. Never show clients anything that isn't photographically competent or doesn't make the subjects look their best. Your first Polaroids should be used to check your lighting and set. As you make progress you will want Polaroids to show perfect body position and facial expression.

When we sell a boudoir session we use the fact that we shoot with Polaroid as an important selling point. We keep a guide book of Polaroids that help us keep track of previous set-ups, lighting diagrams, propping, and all of the details of former sessions. We explain to the client that there will be no surprises when she comes in after the session to review the film. In fact, she will have a very good idea of what to expect before final film is even shot. If the client accepts the Polaroid there will be no later basis for an unpleasant reaction to the work presented. But also remember to explain the limitations of Polaroid to your client, so she will know enough not to judge final color or sharpness by viewing a Polaroid.

CAMERAS AND ACCESSORIES

Our boudoir photo sessions are photographed almost exclusively with a Hasselblad, for many reasons. First and foremost, the 2¼ × 2¼ format is very familiar to us. Bob has been working with a Hasselblad since his days at Capitol Records almost twenty years ago. The 120 format is a great size for portability and rapid use. It readily converts from Polaroid to roll film and yields images that can be enlarged to 30 × 40 inches. The results are always superior.

We use a Hasselblad EL model because of its motor driven film advance, and we also have a standard model Hasselblad for those rare occasions when there are motor problems. Our lens of choice, at least 80 percent of the time, is Hasselblad's 150mm, with only occasional use of the Hasselblad 80mm. We would highly recommend a good quality mid- to long focal length zoom lens that offers exact framing and a variety of results from the same camera position.

There are dozens of good cameras in the marketplace. Select one that fits your needs, and stick with it. If you are looking to purchase a camera or lighting gear, be sure you buy a system that can grow as your abilities and needs grow.

It is important to have a flash meter of good quality. We find it especially useful for measuring the ratios between your different light sources. We use an older Minolta meter that reads in ⅓ stop increments, and has proven to be very accurate and reliable over the years.

As we have already mentioned, having a Polaroid film back is extremely important to our business, as we use it to help us to determine exposure, composition, and lighting ratios, and to show the client a final Polaroid before going to film. There are Polaroid film backs available for most sizes of professional-level equipment. We use a Polaroid film back sized to fit to the back of our Hasselblad for our boudoir business, and we also have extensive experience with using Polaroid film backs on 4 × 5 and 8 × 10 formats. The larger formats are typically used for product and still-life photography.

Very seldom do we shoot without some kind of enhancing filter over the lens. Typically we use warming and diffusion filters. All types and brands

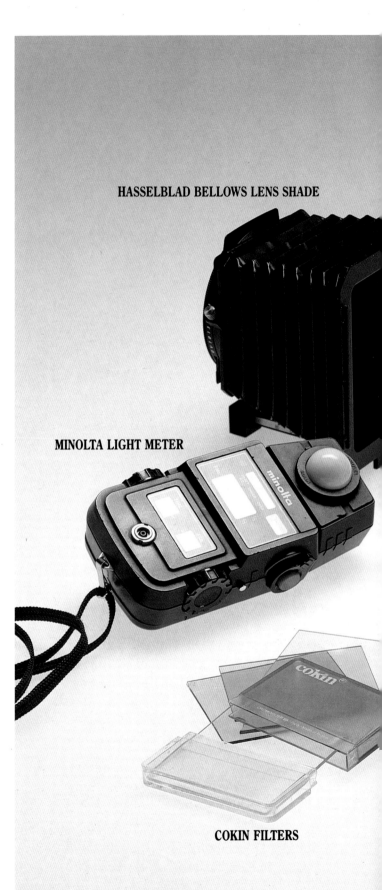

HASSELBLAD BELLOWS LENS SHADE

MINOLTA LIGHT METER

COKIN FILTERS

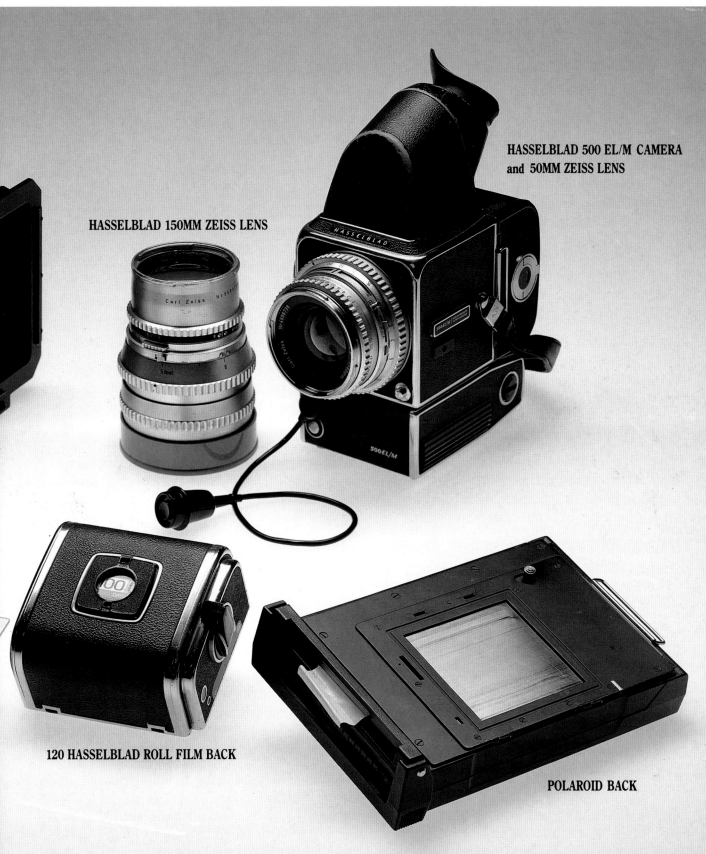

HASSELBLAD 500 EL/M CAMERA
and 50MM ZEISS LENS

HASSELBLAD 150MM ZEISS LENS

120 HASSELBLAD ROLL FILM BACK

POLAROID BACK

are available. We usually use Cokin filters because of their pleasing results and ease in adapting from one lens system to another. For diffusion filters we use their Diffusion I and Diffusion II and on rare occasions, for those tougher clients, both filters at once. For "warming" the overall scene we use an 81A or an 81C, depending upon the amount of warmth we are trying to achieve.

We use many other tools, such as digital kitchen timers for the exact timing of Polaroids, and ziplock plastic bags to help keep exposed film separated. What we have described is our basic equipment. There are all kinds of formats and brands available. Find what works for you and be consistent, to make these tools produce results.

LIGHTING EQUIPMENT

We use electronic flash for almost all our photography. Although there are several quality manufacturers of studio equipment, we have chosen to use Balcar gear and have been very satisfied with their equipment and service. The advantages of using electronic flash to light your subjects include:

Short flash duration. The duration of electronic flash is very short and consistent. This is an aid in capturing those "spontaneous shots," and virtually prevents subject blur and camera movement.

No heat. This is a major advantage when doing boudoir photography. Tungsten lighting can become uncomfortably warm for your subject, and rapidly starts to melt makeup.

Color temperature. Strobes are color balanced for use with daylight film. This is a tremendous advantage when doing location photography, when you may frequently be mixing electronic flash with natural daylight.

Electronic flash gives the photographer a great deal of portable light that can be easily modified and adapted for your specific needs. A number of tools for modifying light are useful, including:

Reflectors. The most basic lighting control tool you will use is the electronic flash head reflector. Its function is to get all the light going in the same direction, and it is available in several types. The flat disc gives you relatively even lighting in a 180° area, and is primarily used in conjunction with um-

brellas. Depending upon their design, reflectors can give you anything from a very narrow to a wide beam of light. A large-diameter reflector will give you softer, more flattering results than a small-diameter reflector.

Reflector attachments. There are any number of attachments available to modify the light from a reflector. The ones we find most useful are grid spots, light deflectors, and barn doors. A grid spot controls your light to give you a tighter beam of light with soft edges. A light deflector is typically used in conjunction with a large-diameter reflector, forcing all the light from that source to be reflected. A light deflector blocks the light from escaping straight off the flash tube, which gives the user a much softer result. Barn doors are used to block light from large areas of a set and help give you control of the overall mood.

Diffusion materials. One of the most basic ways to soften light is by using some sort of diffusion material between your light source and subject. The farther the diffusion material is from your light source, the broader your light and the softer your result will be. Some useful diffusion materials are large rolls of tracing paper, shower curtain material, white bed sheets, spun glass, and translucent acrylic. It is important for your material to be as close to neutral white as possible. Slightly warm in color is satisfactory but cool will not give a pleasing result.

Umbrellas. The lighting umbrella is available in a variety of sizes and surface materials. We only occasionally use umbrellas and typically use three- to six-foot diameter umbrellas that have a matte or semi-matte white reflective interior covering. The umbrella is used to expand a small light source that is directed onto it into a larger one. With the larger light source you then create a more flattering light for portraiture.

Softboxes. We typically use softboxes, or lightboxes, in almost all our boudoir set-ups. The type we have found to be most useful are the Prisma Light Boxes, or PLB's, designed for the Balcar system. The PLB's yield an easily controlled, soft quality of light that is very glamorous and flattering. The light quality from the PLB's is soft and directional without the light getting too "mushy." If

The equipment we use for our boudoir photography
includes, from left to right, a small, 12" × 27" Balcar
Variable Prisma Light Box, a larger, 12" × 43" Balcar
Variable Prisma Light Box, strobe heads with reflectors,
and a 4' × 8' Balcar Galaxy Box.

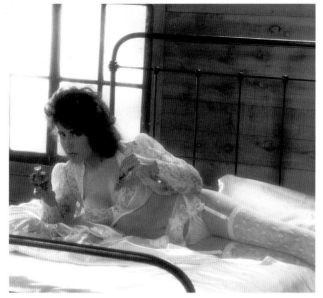
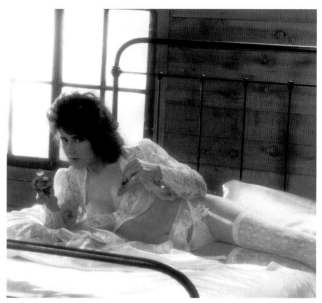

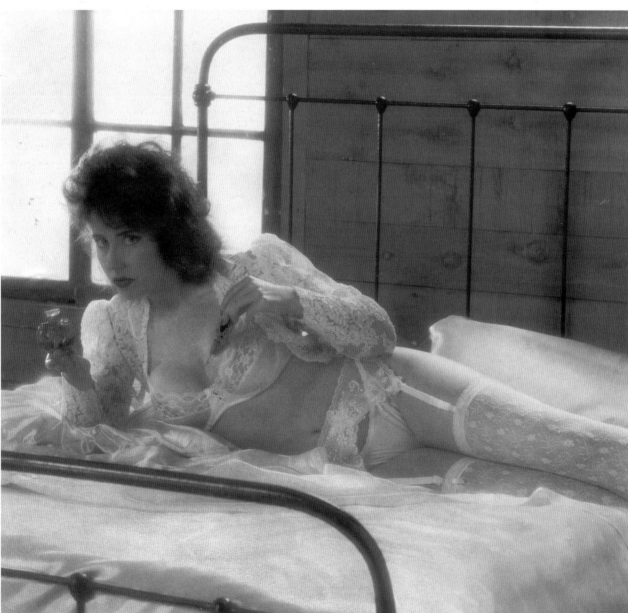

you look at the lighting diagrams in this book you will notice one or more PLB's in most set-ups.

The PLBs—or Balcar Variable Prism Light Boxes—we work with come in three sizes:

PLB #V-PLB30 is 7″ × 13″;
PLB #V-PLB65 is 12″ × 27″; and
PLB #V-PLB110 is 12″ × 43″.

Other types of softboxes we frequently use are the Galaxy-Wall and Galaxy-Ramp. These are both Balcar tools and function as very large softboxes that give a soft but directional quality to light. They are useful as main lights as well as sources of broad, very controlled fill light. These last two items were purchased for our larger commercial photography projects and have proven to be useful; but they certainly are not mandatory for boudoir work.

The Balcar Galaxy Box is a 4′ × 8′ soft, reflective light source. We nicknamed this light "the clam" because of the way the box can be adjusted, opened, or closed.

Reflector boards. We use large white foam-cored reflector boards to lower the contrast of a shot. Light is reflected back into shadow areas of the set, lowering the highlight-to-shadow ratio and cutting the contrast, with the result being softer, more flattering light. The same can be achieved by using another flash head, but that method can result in an unpleasant second shadow, and also uses that frequently precious last light that might prove more useful somewhere else in the set.

Other light modifiers. Frequently we use color gels, "gobos," and "cookies" to further modify the light for our specific requirements. The color gels are used in front of a light source to modify the color of the light. They are particularly useful for creating an early morning or evening light coming

through the window of a set. Gels are available in an infinite variety of colors and do wonders toward helping to achieve special moods.

A gobo is simply a cutter or a card that we use to divert or redirect light away from a subject, to block off any unwanted, stray light, especially if it might flare into our lens.

A foam-cored board with a pattern of holes cut in it is known as a cookie and is a very useful tool in helping to create a mood. Different-sized, free-form holes create the quality of dappled light you may get from sunlight coming through a tree, an atmosphere we mentioned earlier. Long, narrow, parallel cutouts yield the type of light you may get coming through window blinds.

FILM, PROCESSING, AND PRINTS

When working with our regular Wortham Photography clients, we use Fujichrome Transparency material, usually ISO 100 speed. Because we will ultimately need Type C enlargements, we usually use Fujicolor Print Film, also ISO 100. For black-and-white work we use T-Max 100.

We send all our color work to a professional color house that handles our custom enlargements, spotting and mounting for us. We work with color negative film because the characteristically contrasty results of Cibachrome are too drastic for boudoir portraiture.

Another way to give your client something unusual is to shoot black-and-white film while you are shooting color, or make a black-and-white print from your color negatives. Sepia toning these prints or hand-coloring them will produce a print with a very classic feel. We usually use Marshall Oils and Pencils, and the results are worth the extra time and effort when clients buy sepia and hand-colored prints in addition to traditional color prints.

Different moods are created when a black-and-white print is made from a color transparency (top left) and sepia-toned (top right) or hand-colored (bottom).

Handwritten note:

session, possibly this (Provided I've conquered the "stria distensa", ie, stretch marks, and "le flab" by then!). So far, progress has been good, though.. I have a couple of girlfriends who are interested in photo sessions (both totally gorgeous)--do you have a brochure or any informative material I could pass along to them?

Also, Kitty's baby is due on the 10th of this month--think.

Typed fragment (left):

true for me pe...
loving" feelin...
and it felt ...
There was so...
would be so ...
photos as a ...

All my exp...
on J.R.'s ...
the proo...
me feel ...
how pro...
young ...
always ...
very ...

Typed letter:

...Becker
...treet
...Ca. 91203

Dear Bob and Roxanne:

I would like to thank you for one of the most marvelous, sensational experiences of my lifetime.

Both of you are extremely professional, warm and sensitive individuals. It was because of these qualities, and personal attributes, that I felt so motivated to do this boudoir photography with you. You were the first studio I contacted, and I was not looking for another studio. I was totally impressed at our consultation to go with you, that my perception about you and your work, and the end-product would be a gigantic understatement...

Being a 41 year old, divorced, mother of a 19 year old daughter, and with a strict religious upbringing of "No No's", I finally felt the security and confidence in myself to do photography and your motivation came from J.R. my wonderful boyfriend. He was so supportive in making me feel confident and always brings out fabulous positive feelings in me about this woman he thinks I have a great body on... His personal opinion gives his favorite woman a super, erotic ego...

"...in personal expression, and "right-on", understatement." it was...

scheduled for a Saturday morning, I did have a little apprehension, I But, my desire came immediately by Bob and put at ease as a model... my hair... got pampered make-up and styled my session... I felt at ease on the session... professional touch on the settings and they did entirely comfortable... it was a dream come...

Advertising for Clients

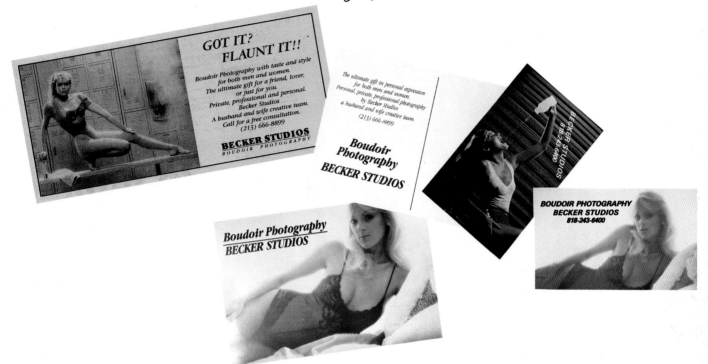

Because of our extensive background in advertising and commercial photography, we understand the basics of putting together effective advertising in order to procure new business. The first step is to figure out the four basic "P's" of marketing: place, product, price, and promotion, and apply them to your specific business. "Place" covers your target demographics, as well as your option to do studio versus location work. Ask yourself such questions as: Who do I want to target with my advertising? Am I in an overcrowded market? How far will a client drive to my particular studio? Will I do location work?

When thinking about "product," ask yourself the following questions: What format am I going to shoot? What are the benefits of this format? Will I offer retouching? How large a print can I effectively sell? Will I present my client with a proof book or slide show?

"Price" will include everything from how you want to position your studio, to what the local market will bear for boudoir photography. In Los Angeles some photographers advertise their boudoir business in combination with wedding packages. Others offer the lowest prices in town. Our studio, on the other hand, offers a deluxe package, which commands higher fees. So you must decide how you wish to position yourself within the marketplace.

When you analyze "promotions," we recommend that you investigate local magazine rates and newspaper rates, in order to come up with a campaign for your studio that you can introduce and grow with. The key is to be consistent when advertising. If you constantly change your image or message, you will lose the identity you created through your previous advertising. Sample concepts we've used are: "Boudoir Photography, Because You Deserve It" and "Get It, Got It, Flaunt It!", which was extremely effective for us when we advertised within health clubs.

We suggest you not only investigate general interest magazines and newspapers, but consider specific market segments. For example, we did very well by advertising our studio's services within the local athletic community. To us it was just natural that people who took good care of their bodies would be more inclined to want to capture

themselves on film. With this premise, we constructed a gym-like environment, with a bank of lockers, a bench, and several other pieces of athletic equipment. Advertising in an athletic magazine brought us more business than we could handle. Along with our classic bedroom sets, our athletic set proved to be another dimension that was attractive to our clients.

When promoting your studio, do not underestimate the power of public relations. You could not have imagined the amount of exposure our studio received from newspaper, radio, and television interviews. Send out professionally prepared press releases; you'll find that, by adding a new twist or angle to your "story," you may be able to take advantage of some wonderful endorsements and exposure.

When we first started to promote our studio, we realized that we would have to separate our boudoir clientele from our advertising/commercial clientele. We decided to rename the boudoir business Becker Studios to clearly distinguish this business from Wortham Photography, and created a new logo and set of business cards. We also printed up approximately 1500 promotional postcards and information/rate sheets. We even exhibited a selection of our favorite 30 × 40 enlargements in several trade shows, which gave us a good amount of exposure. We also attended wedding fairs and expos as well as athletic/health fairs. Initially this campaign worked for us very well, so that when our client base began to expand we were able to rely more and more on word-of-mouth referrals to our business.

You can increase your amount of referral business if you develop an incentive program, such as the one we offered, giving away a free boudoir session to any client who referred four or more customers to us.

When advertising our boudoir studio, we try to present a creative, professional image to attract clients. As you can see in these three photographs, our approach to boudoir photography goes far beyond shooting "classic," expected pictures. Our promotional material reflects our diversity and our innovative strategies.

HOLIDAY OR SEASONAL PROMOTIONS

As a boudoir photographer, you will soon learn that holiday and gift-giving seasons are the most lucrative time for your business. It's to your advantage that there seems to be an endless array of props available during a specific holiday. You must learn to think and plan ahead with holiday periods: not only will you have to place the appropriate advertising early, but in order not to miss your clients' gift-giving deadlines, your props will have to be ready.

At Christmas or Valentine's Day, for example, make sure to collect props at that time for use the following year. For many women, finding a special holiday gift for her man can become a nightmare. One or our satisfied clients was delighted at the thought of solving this problem by giving her husband a holiday boudoir portrait, saying, "He has everything! This is the only gift that I alone can give him." She plans on giving him a different portrait every year. Now *that's* repeat business and it's important to remind clients of its availability. Any major gift-giving season should give a generous boost to your business.

Remember to give yourself plenty of time when advertising and shooting for holiday deadlines. There are a few things that you can do within a tight deadline:

- Use a Polaroid print from the session in a card.
- Make up a small book of proof prints for your client.
- Sell attractive gift certificates to be redeemed after the holidays.
- Keep new or well-cared-for props that pertain to the holiday you are shooting.

All kinds of interesting opportunities avail themselves when you start asking potential customers to fill out a simple questionnaire. Keep in mind that you are looking for the information that will make a boudoir shot unique. This will also give you a satisfied customer and a tremendous potential for referral business. Playing up a client's or her loved one's hobbies is almost always a sure hit, with sports being just one avenue to follow.

Christmas and Valentine's Day aren't the only holiday themes that work well for boudoir portraits. This Halloween set, complete with cat, cauldron, and candles, allows clients to look provocative and playful.

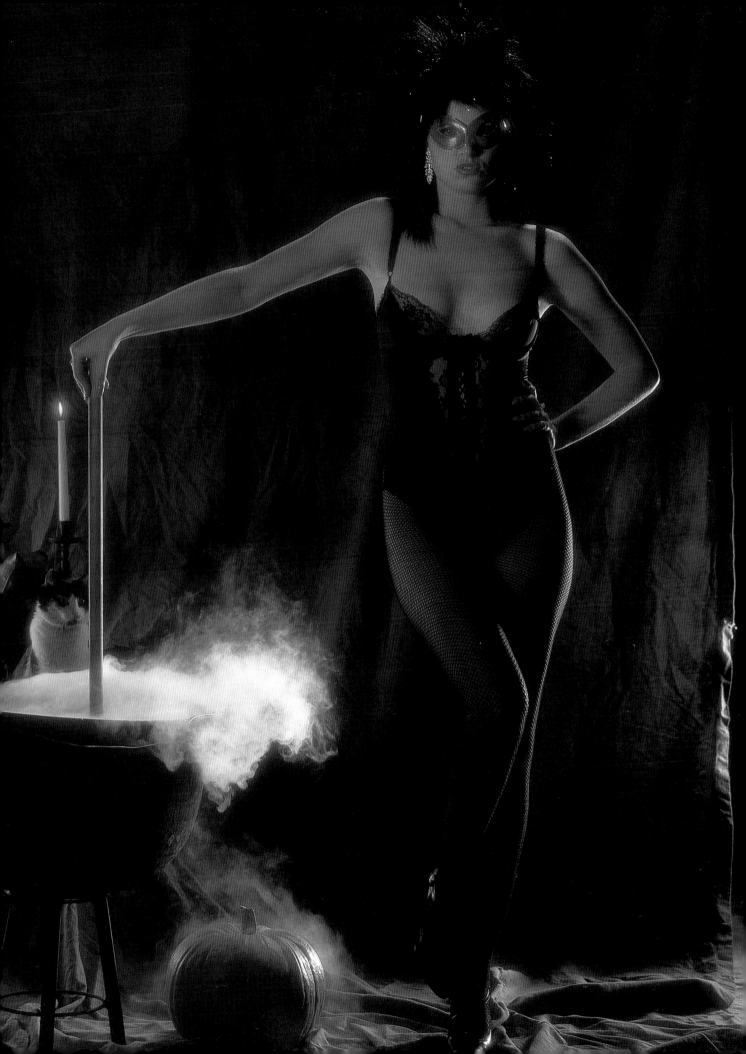

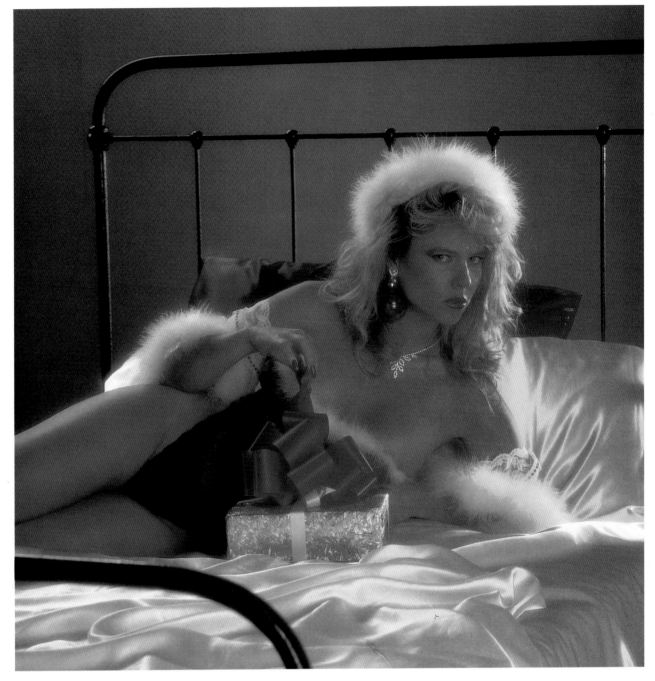

The perfect Christmas gift: a boudoir portrait of a model bearing presents. The bright red props make these two images particularly festive and appealing. Both the eye-level perspective in the photograph above and the overhead view opposite are flattering.

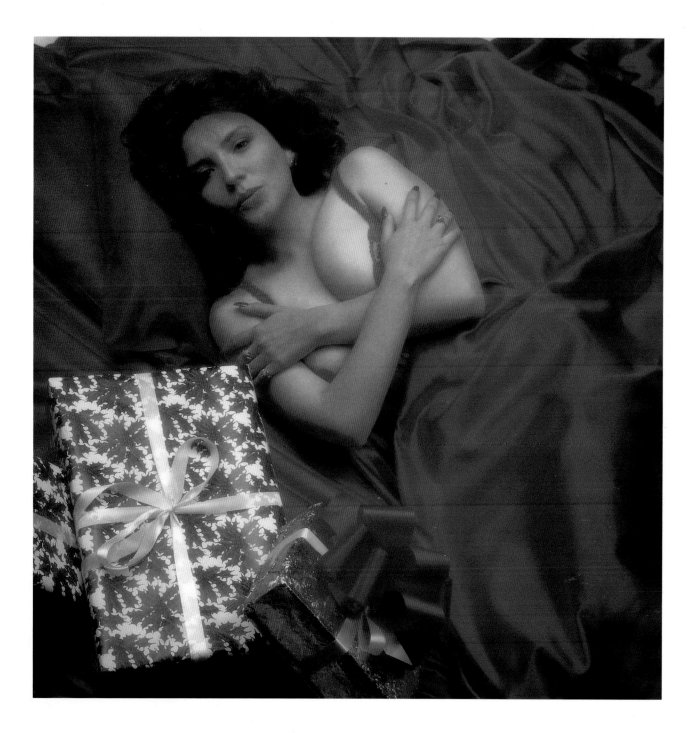

In Summary

■ Be sure to walk before you run. Practice makes perfect, so start out slowly and then progress.

■ Remember that Polaroids are cheap insurance for the success of a session, both technically and aesthetically. Since your clients must feel comfortable and happy with the results of the work, show them only final Polaroids.

■ Maintain a professional attitude and discretion at all times. You are dealing with a delicate subject.

■ Remember that the individual needs of your client will vary. You will encounter everything from aspiring models to women who want the photos simply for their own enjoyment.

■ Above all, keep your ideas fresh. Try new sets. Go after new market segments. Expand the boundaries of your business.

■ The fresher and more contemporary your techniques, the more business you will do.

This shot reflects a subtle approach to a Valentine's Day boudoir portrait. Rather than use the traditional props—a heart, a box of candy, and lacy, red lingerie, we decided to pose this model eating the candy from the open box and wrap her in red, silver, and pink ribbons.

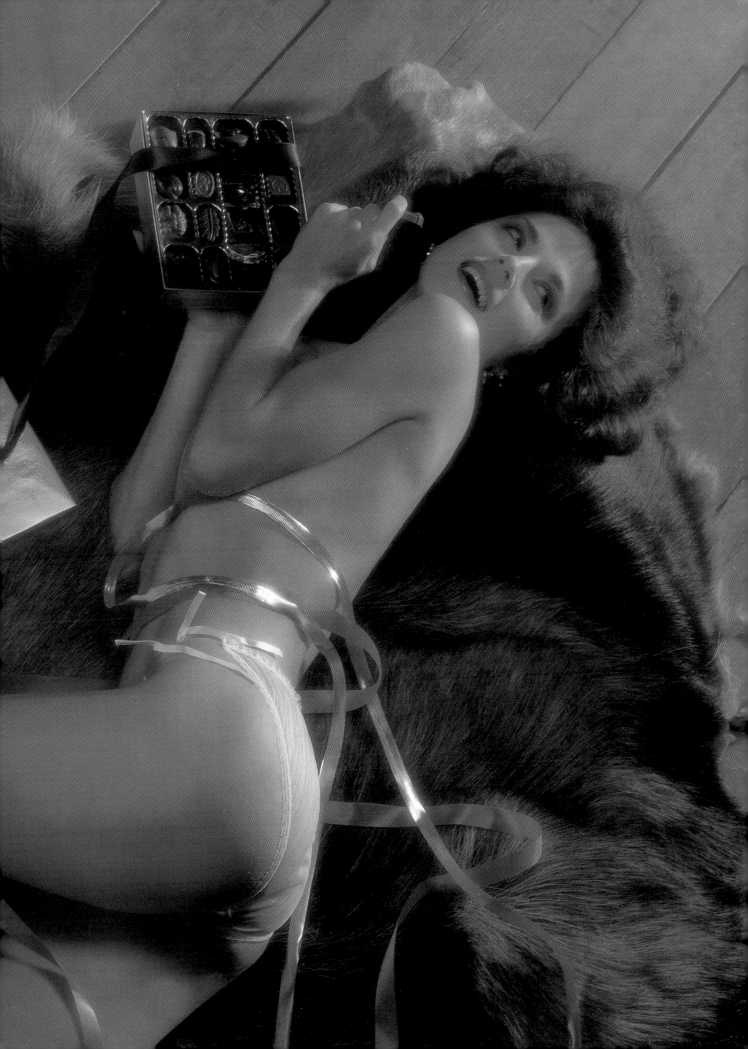

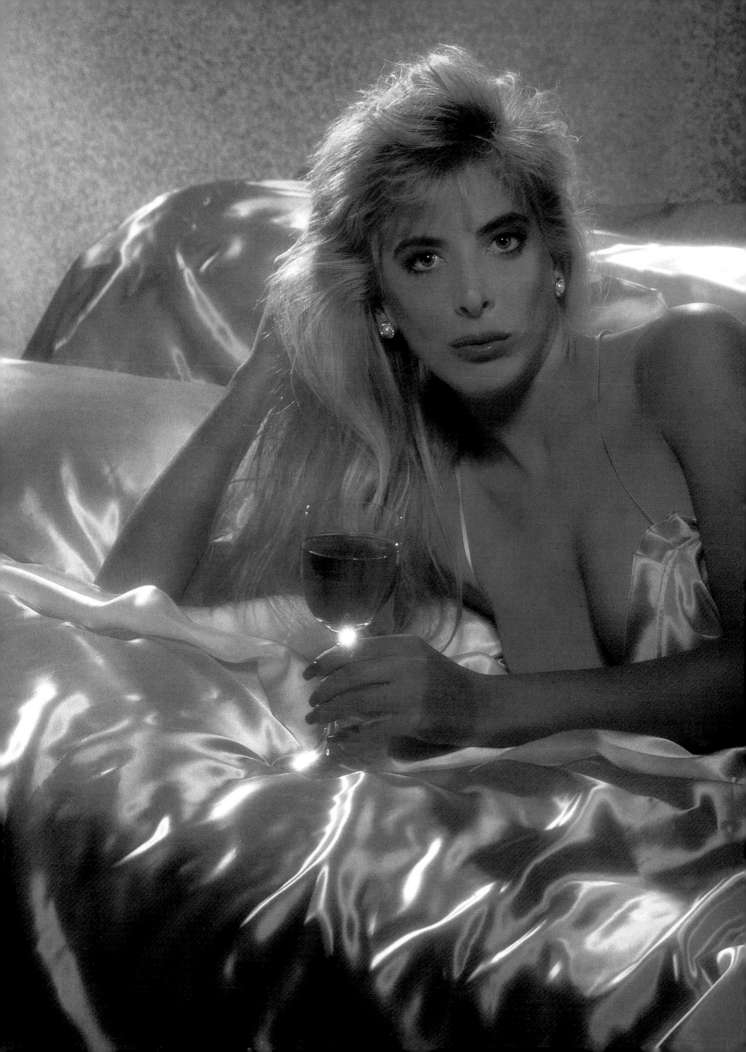

PART TWO

Styling the
Model

Styling the Model

MAKEOVER AND WARDROBE are two major aspects of a boudoir shoot, and they are areas where a professional stylist can become very valuable. Stylists function in a variety of ways. In the world of professional photography, stylists primarily take the detail work away from a photographer, so that the photographer can concentrate solely on the photographic aspects of a shoot. Stylists also have specialties. Hair stylists just work on styling hair, while wardrobe stylists procure, organize, and even press or alter clothing, and makeup stylists only apply makeup. There are even food stylists who work in the area of professional photography, purchasing and preparing food, transforming it into photographic perfection.

In our business, we use one stylist for both makeup and hair. We have our favorite stylists, but we do keep a backlog of potential backups in case our stylists are booked on other jobs. Our stylist is expected to offer input regarding the color or style of the wardrobe, but she will not procure or iron a client's clothing, since we have counselled the client in advance, and we expect her to arrive on the day of her shoot prepared. We keep an iron and ironing board on premises for touch-ups. But there is much more to wardrobe preparation than ironing, however, and many a shoot has been saved because a conscientious stylist brought the proper tools for pinning, tacking or altering a garment. The stylist will also help dress the client, so she does not disturb her hair and makeup.

We work only with professionals, a good habit we developed in our commercial business, and a policy we urge you to adopt. We highly recommend, if you cannot afford to hire a professional, or if you work in a rural area away from a major metropolitan city, that you train someone in these skills. The last thing a photographer has to be concerned with is looking for a safety pin to fasten a too-large teddy!

Most stylists know enough to come well prepared for a photo session, with all of the tools necessary to complete their jobs independently of the photo studio. On the theory that it's better to be over-prepared, however, we keep a supply of

This photograph is a stylistic success. Every element exudes elegance: the silk lingerie, the pearls, the upswept hair, the wooden chair, and the rich background. Working with a stylist who is creative, detail-oriented, and organized makes your own work easier—and your photographs stronger.

42

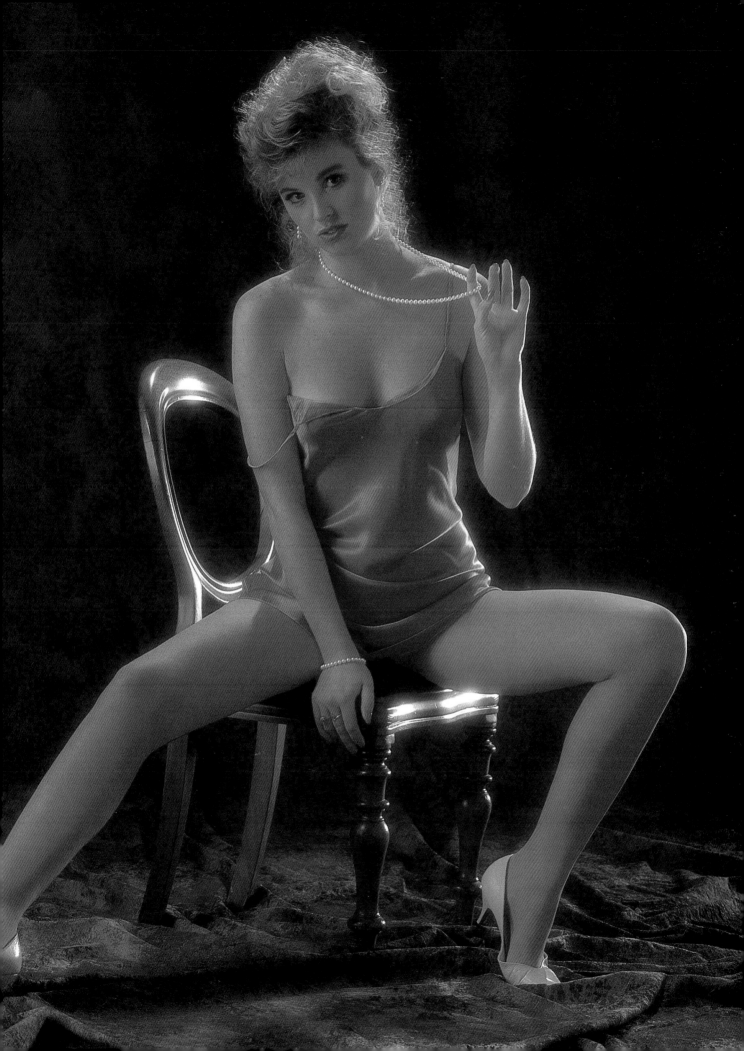

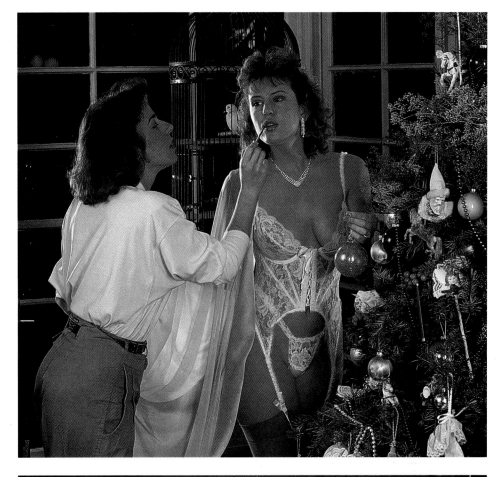

When we arrived at this client's home during the Christmas holidays, we found this lovely tree decorated in nontraditional colors. They worked well with the model's pastel blue and pink lingerie. The dove cage behind the model was another beautiful—and lucky—touch. Visiting a chosen location before the actual shoot and using a client's personal possessions as props helps to make the session more comfortable and the photographs more individualized and special.

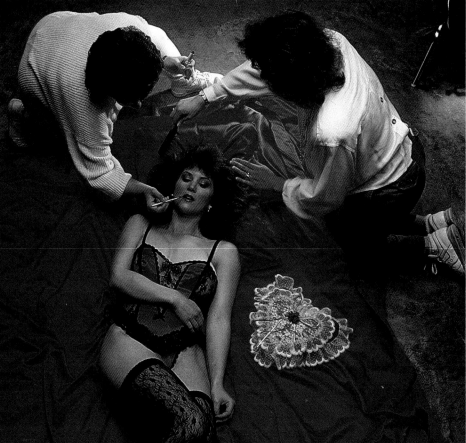

The use of lingerie, textured hosiery, props, and a rich, satiny background creates the sexy look many models look for, especially for Valentine's Day presents.

items handy, including: a blow dryer, hot rollers, curling iron, iron and ironing board, tissues, mirrors, clamps, safety pins, sewing kits, scissors, and clothespins, among others. An unprepared stylist will reflect badly on *you* and *your* studio. As insurance, we test with new stylists on a regular basis, and suggest you do the same. Many stylists are willing to test with photographers in exchange for photo prints showing their work for their portfolios. (In the same way, friends or budding models are also often willing to test or work for free with a photographer in exchange for photographs.) In trying out a stylist, you will want to observe the way she works with clients, since your stylist is very instrumental in keeping a client at ease during her makeover. A good stylist will complement a client's own assets, and help the client feel confident and attractive.

Remember that a good makeover will run approximately 1 to 1½ hours, with stylists varying in how they handle hair. Some will immediately start by moussing and putting hair in hot rollers to "bake," while they work on the makeup. Other stylists clip hair away from the face, and then, only when the makeup is finished, they mousse, roll, and spray hair into place. Since either method works well, we leave the choice up to the individual stylist.

HAIRSTYLING

As we stated, in our studio we rely upon one stylist to perform both the makeup and hairstyling on our clients. We request the client to arrive at the studio on the day of her shoot with freshly washed and dried hair. Most stylists prefer that the model not apply any mousse or gel prior to her arrival for the shoot. The stylist will apply the gel, cream, spritz, or mousse necessary for the appropriate look. For the most part, mousse is applied and then hair is rolled with hot rollers. Curling irons are primarily used for touch-ups. Sometimes, in order to get difficult hair to cooperate, a stylist will use hair spray after the initial mousse application and hot rolling and then re-roll hair with hot rollers. Gels and other lotions are usually used for the "wet" look, which is often appropriate on our jungle-pond set or any water-oriented set. Remember that, after makeup has been applied, care must be taken when working with a client's hair, and clients should use their hands to cover their faces when hair spray is being applied. Extra care should be taken if a wet look is decided upon after the makeup job has been completed, so as not to undo hours of work with an accidental smear of gel on the face.

It is also important that a client not wear any makeup or even foundation when she arrives for her session, since it can take work to remove old makeup. If the session is a surprise for a loved one and your client has to leave the house with makeup on, make sure you have a gentle remover on hand, so as not to irritate and redden the skin. Soft cotton wipes are also important to have on hand, as tissues can scratch the skin.

We also recommend to our clients that they arrive at the studio with polished nails, including toenails. No matter what length a client's fingernails are, they should *always* be polished, to avoid an unfinished look.

The Makeover

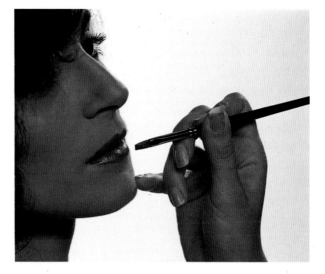

It is said that a model's makeup can make or break a photo session. We strongly agree, and always emphasize a well-done makeover for a client. Over the years we have had the pleasure of working with several excellent makeup artists and have learned that each artist has a distinct style. As photographers, we have definite ideas of how we like makeup to look. To us, the basics of a good makeup job include the following:

- The makeup should even out the client's skin tone.
- The blush, eye shadow, and lip colors should be applied in such a manner that they do not detract or overpower, but enhance a woman's features.
- Above all, the makeup should look fresh, clean, and contemporary, and have a healthy sheerness.

When these guidelines are not followed, a perfectly pretty woman can end up looking cheap and sleazy. We cannot overemphasize the importance of makeup competence in boudoir work.

Practice and experience will make you confident about the direction each makeover should take. While you're still learning, try using tear sheets from magazines and beauty books as camera-style makeup guidelines. To this day, we still work with tear sheets. They are valuable tools for communicating ideas and concepts to makeup artists, stylists, and clients.

PHOTO MAKEUP

Street makeup, or everyday makeup, differs greatly from photography makeup in several respects. To begin with, coverage, shading, and highlighting are not usually a part of normal street makeup. The application of camera makeup is slightly heavier than street makeup. There is also a distinction between general glamour makeup and high-fashion or stage makeup. High-fashion makeup and stage makeup are often very overstated and dramatic, and is quite different from the clean, fresh approach to makeup that boudoir photography requires.

The street makeup women wear tends to be either outdated or very trendy. Baby-blue eye shadow has been out since the 1970s; however, many women still use baby-blue shadow on their eyelids, despite the fact that it totally overpowers the eye. Another example: heavy black eyeliner on very pale skin can be a very trendy look, but it is not appropriate for a glamour approach. Street makeup involves using quite a few pencils, but makeup for the camera requires more solid permanent liners and bases. Also, colors tend to fade quickly with street makeup but not with photo makeup. Women can sometimes look very "clowny" by placing blush in a circle on the cheek. This is to be avoided. Blush should blend in so it is not noticeable.

Finally, street makeup tends to be more personalized, in order to express an individual's personality, whereas glamour makeup is usually dictated to coordinate a model's face with her wardrobe and environment. In boudoir photography, because the model is hiring the photographer, you must take into account her feelings about the results of the makeover. She might not want too much makeup on, no matter how good you feel it would look on film. Our experience is that *all* clients need *some* makeup. If none is applied, the camera will not be able to clearly distinguish the lips, cheekbones, and face. So suggest that some makeup be applied for all sessions, but ask your model some questions before you have makeup applied. Make it clear to her that photography makeup doesn't necessarily mean heavy makeup. Photography makeup can be sheer. Also, ask her to remove her contact lenses if possible. Sometimes they make the eyes more sensitive to light. Moreover, powder could fall into her eyes during the makeover, causing irritation.

A makeover can be divided into seven separate areas: base and foundation, contouring and highlighting, eyebrows, eyes, lips, hair, and touch-up. We cannot cover the endless varieties of makeup application for photographic purposes, but we do want to list all of the basics, as a starting point. Remember that applying makeup well takes practice. As you progress as a photographer, having at least a basic understanding of the application procedure and materials will help you visualize how makeup will translate onto film.

Basic Cosmetic List

- Cosmetic sponges
- Powder brush
- Blush brush
- Eyebrow brush
- Lip brushes
- Powder puffs
- Pencil sharpener
- Moisturizing facial cream
- Foundation, with a minimum of five different shades
- Blemish cover
- Eye shadow
- Blush, with a minimum of two shades
- Eyebrow pencils
- Eyeliners
- White highlighter
- Mascara
- Lipsticks
- Lip gloss

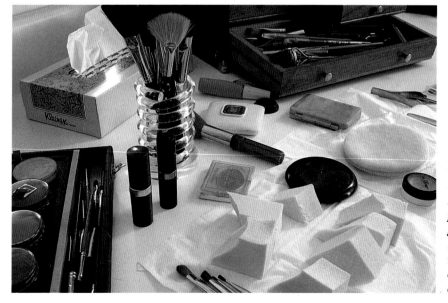

Our makeup artist has a large assortment of cosmetics and makeup instruments on hand, including many different brushes and sponges, eye pencils, lip glosses, and lipsticks. She is ready for any client—and any emergency.

This client's beautiful skin and good bone structure made her transformation relatively uncomplicated. Because the model has ash blonde hair, pale beige skin, and blue eyes, the makeup stylist used only rosy, gray colors and a deep pink lipstick. This cool palette complemented the cool feeling of both the model's outfit and the set.

BASE AND FOUNDATION

To begin your makeover, pluck any stray eyebrows before applying base. "Base" is the liquid or cream used as part of the overall foundation, which includes powder and blemish cover. Make sure you are starting with a clean face, without traces of any other makeup. Evaluate your model's skin color, and then proceed with a foundation that is slightly darker than her skin. Completely cover the face, including eyelids, lips, ears, and also the neck and hairline. You must do this so makeup contouring and shading will stay in place longer. By placing base on the lips you will help set the lipstick and prevent it from bleeding below the lip line. After base is applied check for smoothness and an even application. Take your sponge and buff the makeup down, to eliminate a heavy look.

Now check underneath the eyes. If you see blotchy skin or dark circles, place a blemish cover under the eye and redo the base coat. Orange highlight will neutralize red blemishes. You can place the orange highlight in the inner eye corners if they are red, too. Use the base that is still left on your sponge, and blend "Mellow yellow," a well-known blemish cover, and orange highlight can be purchased at any beauty supply store. Bases can also be purchased at a beauty supply store in creams, powders, or liquids. Once the base coat is applied, the face can be completely powdered with translucent dusting or finishing powder.

Our makeup artist prefers to work with powder versus cream foundations because "if you use creams, once you apply a finishing powder you cannot touch up with cream again." Another advantage to powder is that it won't soak into the skin as quickly as a cream base will. If the skin is oily, cream bases tend to slide on the surface of the face. If a model's face is dry, it can drink up the cream base too quickly. Powders also give a nice matte finish that is ideally suited for the camera.

Body makeup is necessary for a client with uneven or blotchy skin tone, any type of discoloration, bruises, stretch marks or even tattoos. Joe Blasco makes a line of tattoo coverup that is good for hiding varicose veins. Pancake powder foundation activated with water is the best body makeup. Always put body makeup on the model after she has put on her wardrobe; otherwise, you risk smearing makeup onto her clothing. Because you are using a powder foundation activated with water, you will want to buff makeup gently with a sponge. This will prevent powder from drying and cracking.

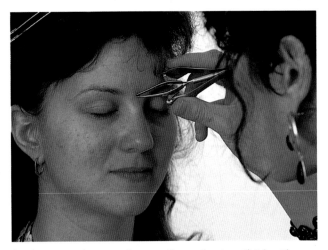

At the start of any makeover, the makeup artist brushes the client's hair away from the face and secures it. She then checks for and removes all stray eyebrows, especially those that appear on the bridge of the model's nose.

Once the eyebrow area is clean, the makeup artist examines the client's complexion and applies base. This step is essential: blemishes are covered, and uneven skin tones are balanced.

This model looked quite glamorous after her makeover. Her darker coloring calls for brightly colored makeup, so the makeup artist applied a deep pink blush and lipstick. For a sophisticated look, the model's hair was curled.

CONTOURING AND HIGHLIGHTING

After powdering the face, you can begin to contour it. Contouring an area on the face with blush makes it recede or slim down. Highlighting, on the other hand, will emphasize or fill out an area of the face. In your makeup kit it is wise to carry several shades of blush, along with white, gray, or light pink powder for highlighting. Lighter shades of blush should be used on fair complexions, while deeper, richer shades are appropriate for olive or darker skin.

Good starting places are cheekbones. If the model has a round face, start underneath the cheekbone and bring the blush out to the middle of her eye to create more of a hollow. With narrow faces, you would not bring the shading in quite this far. Notice the definite dark line on the cheekbone that can be seen after you apply the blush. This is to be blended, or feathered out, from the center of the contour line with short, light strokes. Blending is the most important skill of a makeup artist.

Now look at the shape of the model's nose. If it is too wide, you will want to shade a little along the sides of the nose. If you don't have much experience in contouring, go very lightly until you feel more comfortable. Shading is also very critical. The camera will pick up on a poorly shaded client, and you will have unsatisfactory results. Place highlight down the center of a wide nose or one with a flat bridge. This will "bring out" the nose and create more contrast and depth.

Sometimes you may want to blush along the chin. Remember to blend out only the edges of the blush, and feather out onto the rest of the neck. This creates a lovely, thin jaw line. You may also run a little blush along the forehead. If the model has olive-colored skin, you may want to shade all along the ears and down the neck. For body makeup on olive skin alone, you might get away with just brushing a little blush along the neckline and chest.

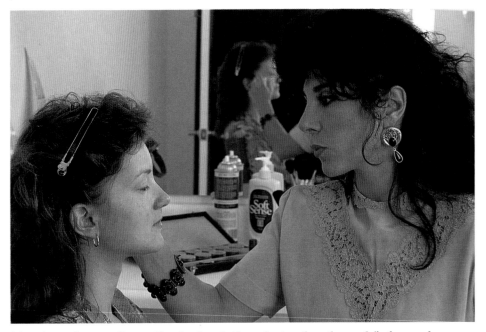

After the makeup stylist applies the foundation, she powders the model's face and decides which areas need to be contoured and which need to be highlighted.

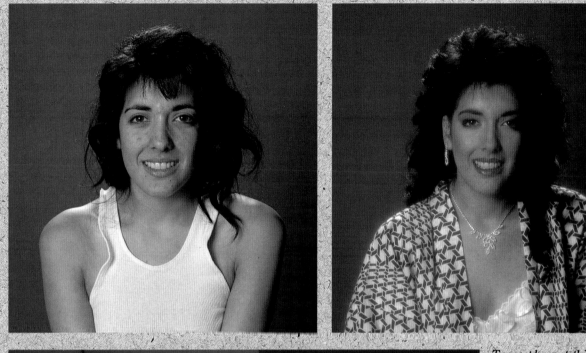

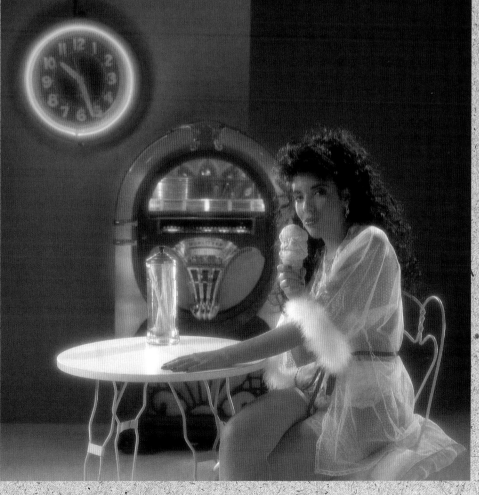

To complement this client's brown eyes, black hair, and dark skin tone, the makeup artist used pink blush and eye shadow and a deep rose-colored lipstick. First, however, she "feathered" the foundation down the client's neck and onto her shoulders, to eliminate blemishes and an uneven skin tone.

EYEBROWS

We have powdered, shaded, and highlighted the client. Now we are working toward doing her eyes. When eyebrows are sparse, you can take a brown powder on a very firm eyebrow brush to fill in the eyebrows. Lengthen them if necessary. Put a small amount of hair spray on your eyebrow brush, and then brush the eyebrows to make them stay in place. Do this lightly, especially over powdered eyebrows.

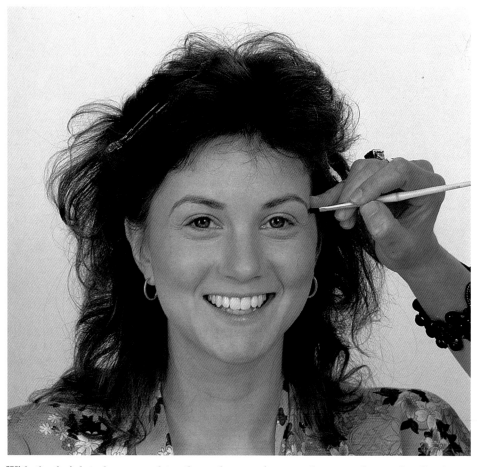

With the facial makeup complete, the makeup artist turns her attention to the client's eyebrows again. When the eyebrows are thin, they are filled in and lengthened so that they will show up in the photographs.

After the makeover, this client was transformed from "the girl next door" into an alluring woman. Her freckles and rosy cheeks were evened out with a warm beige foundation. This skin tone looks best when peach or coral pink makeup is used. To add to the illusion, the makeup artist decided on a curly hairstyle and swept much of the model's hair onto the top of her head.

EYE MAKEUP

First, examine your client for bloodshot eyes, and, if necessary, start with Visine. Then choose eye makeup colors that harmonize with your subject's coloring, her wardrobe, and the set. There are beauty books available that can help you learn to work with color and makeup, and if you are a novice, we highly recommend using one. The rule for eye shadow is to put darker colors on the corners of the eye and lighter colors on the inside of the eye. Never apply eye shadow past the eye corner. If you spill eye shadow onto the cheek, use a brush to wipe it away, rather than your sponge. To uplift the eye, apply a darker color in the upper corner. Contour the eye by using a darker color in the crease of the eyelid. This gives the eye definition. Highlight above the crease.

Liquid eyeliner adheres better than pencil and doesn't melt under the lights. Draw the eyeliner above and below the lashes for more of an accent. Use your sponge if the eyeliner smears or smudges. After eyes have been colored and the liquid eyeliner has dried, it's time to apply mascara to the top and bottom lashes. Apply two, or even three, coats for thickness and length. Keep your client's wardrobe handy to check makeup eye colors against the colors selected in the wardrobe.

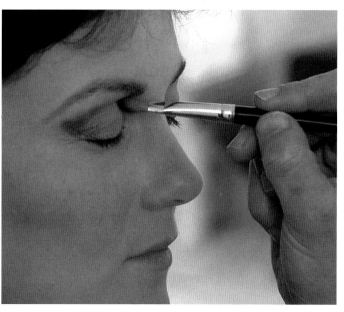

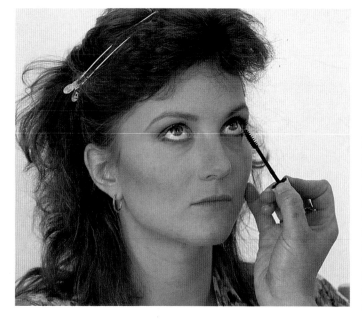

Perhaps the most complicated part of the makeover process involves the eyes. Blending complementary eye shadows is essential to creating a look that flatters the model. Applying eye makeup requires a steady hand, especially when lengthening the lashes with mascara.

This client had great bone structure, an angelic face, large green eyes, and thick brown hair. With these strong features to accentuate, the makeup artist chose a bold approach with this client. The stylist used a dark beige foundation to even out the model's skin tone, dramatic eye makeup, and a bright, reddish burgundy shade of lipstick.

LIPS

Color the outlines of the mouth with a pencil one shade darker than your intended lipstick. Follow the actual lip line; otherwise, the lips will look artificial. Fill in the lips with lipstick, using a lip brush, which will help to keep the lipstick within the outlined area. Test the color on your hand before filling in the lips. Remember you can mix lip colors for just the right blend. Then apply gloss for a shiny finish. That will put a highlight on your subject's lips when she is in front of the lights.

If your model has small lips, you may want to make her lips look fuller by outlining them along the outside edge versus the inside edge of the lip. Don't make the "cupids" at the top of the lips too sharp. Round the points. Another benefit of using lip pencil is that it helps keep lipstick from smearing, in addition to giving you a guideline for a quick touch-up if the lipstick should wear off. Have your client drink all liquids through a straw, to avoid having to re-apply the lipstick completely.

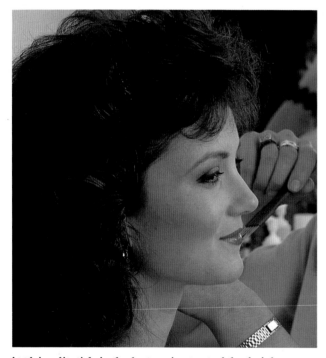

Applying lipstick is the last major part of the facial makeover. Here, the stylist outlines the model's lips and then fills them in, taking care not to create a too-large, clownish mouth.

HAIR AND TOUCH-UP

Look at the whole palette now. You may want to blend or touch up the blush at this point.

Have the model look down, and then check her profile. Turn her head and check the makeup job from every angle. Check for stray strands of hair. Look for "holes" in the hairdo, where back lighting could create a problem. Remember that the hair should be free-flowing, fluffy, and not too stiff.

If any retouching is necessary, use the same sponges, brushes, or other tools you used to apply the makeup. Retouching any makeup should be done slowly and carefully, so as not to smudge the rest of the face. Also, whatever you do, do not use your fingers or hands on your client's face. The oil from your hands can ruin an hour's work.

In Summary

- Makeup should be glamorous, never overdone or cheap-looking.

- Be careful, when touching up a model's makeup, not to smudge the rest of the face with your hands.

- Fill in gaps in the hair that would let light leak through.

- Keep in mind the colors of a client's wardrobe when selecting makeup colors.

- Keep plenty of extra stockings and nylons on hand in case of emergencies.

- Remember that the more time you spend with a client discussing wardrobe, the better off your client's wardrobe will look when you are ready to shoot. Advance preparation and counseling will help avoid "surprises."

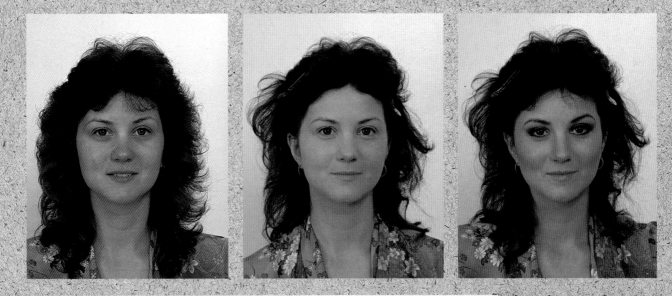

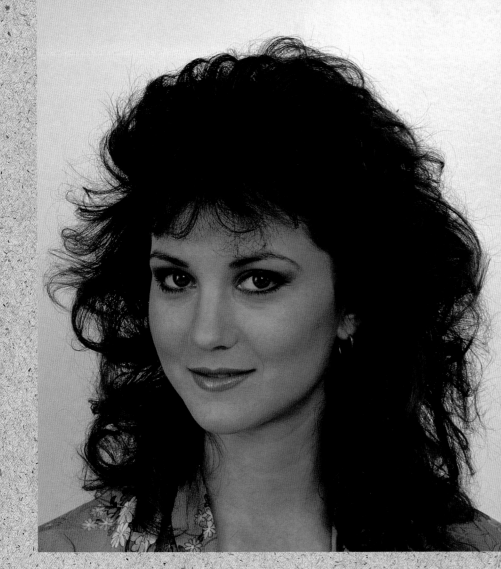

A step-by-step makeover can dramatically change a model's appearance. This client arrived at our studio wearing no makeup and with freshly washed hair. As the one-hour makeover progressed, the makeup stylist prepared the client perfectly for the photo session, with the application of foundation, eye makeup, and lipstick. The creation of a flattering hairstyle was the final element of this undeniably successful makeover.

Wardrobe

Whether you are selecting wardrobe for a client or counseling her about proper clothing for a boudoir session, there are several things to keep in mind. Remember that every woman has unique skin tone and coloring, and it's very important that the wardrobe, makeup, and hair styles you recommend flatter her. Every detail contributes to this end, and to the success of your photo session. We keep various wardrobe items at our studio, although we prefer that our clients furnish their own wardrobe. Our selection consists of several long nightgowns, some teddies, various stockings and nylons, robes, and slippers. We only use our wardrobe to help round out what a client has brought. Nylons and stockings often come in handy if the ones a client has brought are torn.

Any wardrobe looks better when it is properly fitted, especially lingerie. If clothing is too tight, it will pinch the client's skin and, instead of having the slimming effect that some would expect, it will make her look plump and heavier. If she is small-busted and wants to look fuller, suggest that she wear a push-up bra specifically designed to uplift the breasts. Wearing a smaller-size bra is not a good solution. Too large an outfit will look shapeless and unattractive, as well. Although there are ways to clothespin such an outfit to make it tighter,

it is better to start with a well-fitted garment. When working with tunic or roman styles, remember that when your client reclines, the garment may sag and drape improperly. Keep this in mind while consulting with your model in advance.

Make sure your client brings several changes of clothing from which to choose. It's better for her to bring too much than too little, so that, if one specific outfit is not working well in front of the camera, another outfit can be tried. However, a boudoir session is not a fashion show, and the client will become "cold" in front of the camera every time she changes wardrobe, meaning that her facial expressions will become tense, nervous, or distant. We want our models to look natural and relaxed. "Warm," comfortable expressions take time and patience— and not too many changes. If a client insists on more than two outfit changes, reassure her that you want to capture her "perfect" facial expressions and that facial expression is more important than the number of outfits she models.

On the other hand, if a client only wears one outfit, chances are that she will not select as many finished prints for enlargements. You must strike a balance between two extremes. Two to three changes per set is what we recommend. Each change should introduce a different style and color.

COLORS

The classic colors in boudoir photography are red, black, cream, ivory, and white tones, basic colors that will never steer you wrong. The accompanying charts contain some useful tips and guidelines. Remember these are just suggestions. You have to take each individual client into account, carefully considering her own taste and desires. We once worked with a gray-haired client who insisted on a primarily pink wardrobe, while we suggested black. We shot her in both colors. The black wardrobe was superior, while the pink outfit washed her complexion out and made her look drab.

You don't have to be a color expert to develop a good working knowledge of what colors look best on your clients. There are several good books on the market that offer quick and easy color guide systems. Tear sheets from magazines are excellent resources for contemporary color ideas. The more adept you become at skillfully combining colors, the quicker your photography will improve. Using the right colors is a simple way to enhance your photography without buying expensive equipment or taking more photography courses.

Also, the more you learn to work with color, the better you will become at assisting your clients to make wardrobe selections. We always ask our clients, "Why look just all right, when you can look sensational?" Learn to control the color elements within your shot, and you will see a difference in the quality of your work.

In Summary

Be sure to avoid these wardrobe mistakes:

- Stockings that are too dark. They should be matte-finished and skin-toned. Avoid shiny nylons.

- Avoid showing the bottoms of shoes.

- Older clients shouldn't be clad in dark or high-contrast colors. The key words here are softness and diffusion.

- Make sure the wardrobe fits correctly and doesn't overpower with such items as fancy robes and fur coats.

- Be alert for clothing that could seem ridiculous or cheap-looking. Never dress an older woman in a very young woman's style or outfit.

- Watch for a garment or jewelry that pinches.

- Make sure clasps and buttons on garments are properly secured.

- When in doubt about an item of wardrobe, do without!

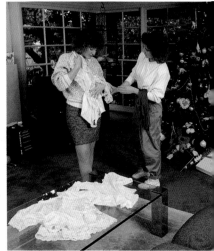

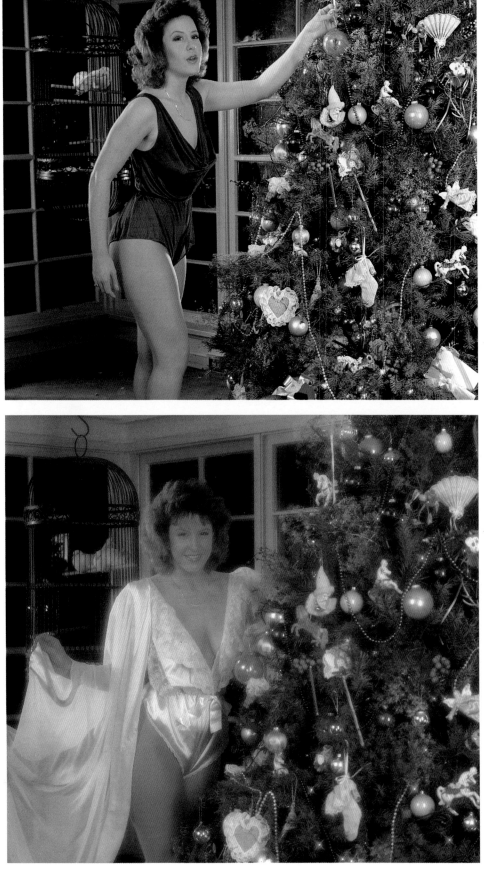

Many on-the-spot decisions about a client's wardrobe have to be made during the photo session. While an outfit can look appealing at first glance, it might not work well with a particular set. When we began to photograph this model, her purple outfit seemed perfect for this nighttime Christmas shot (top left). But we quickly discovered that there was little detail in the shadow areas on the teddy and that its deep color "darkened" the mood of the shot. To overcome this problem, we asked our client to switch to an aqua teddy and a pink wrap (bottom left), which were far more appropriate for this holiday fantasy scene. When working with a model, be prepared to make last-minute changes—and be flexible.

Type A

Use the following charts to help you in your color and wardrobe selections. If your client has the following "Type A" characteristics, your client should wear bright, vivid, blue-based color tones. "Type A" clients can wear black, white, and blue-red tones, avoiding beige and cream lingerie.

The best "Type A" makeup colors are dark pinks/plums or true red for the lips, with burgundy or plum blush.

Skin:
Very white
White with pink tones
Beige
Rosy beige
Olive
Black

Hair:
White
Silver gray
Salt and pepper
Medium brown
Dark brown
Black

Eyes:
Blue
Gray blue
Hazel
Green
Dark brown
Black brown

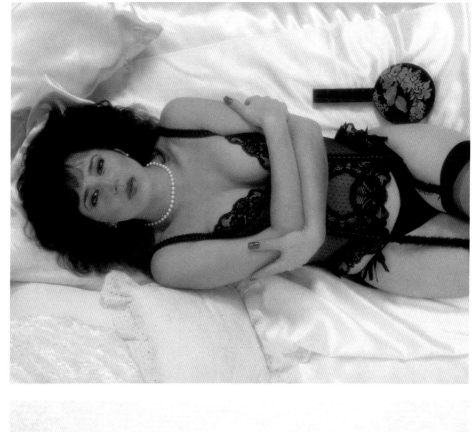

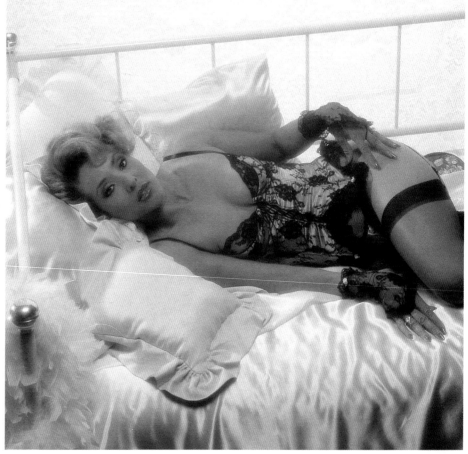

Type B

If your client has the following "Type B" characteristics, your client should wear lingerie of blue, rose, or gray tones. This client also looks good in a "cool" palette—soft blue, navy, rose pink, lavender, and plum shades work very well. The best makeup colors are light pink/rose on the lips, with rose or pink blush.

Skin:
Pale beige
Pale beige with pink tones
Rosy beige
Gray brown
Rosy brown

Hair:
Platinum blond
Ash blonde
Dark ash blonde
Ash brown
Dark brown with
 a taupe tint
Auburn
Blue gray
Pearl white

Eyes:
Blue
Green
Pale aqua blue
Hazel
Pale gray
Rose brown
Gray brown

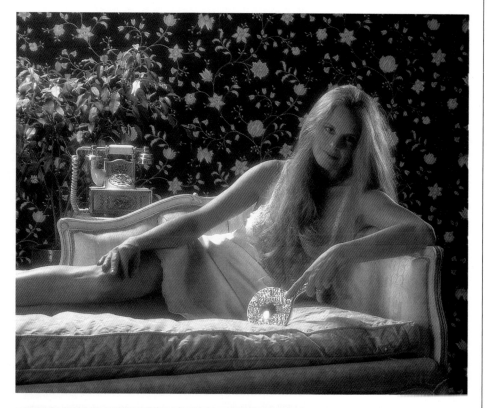

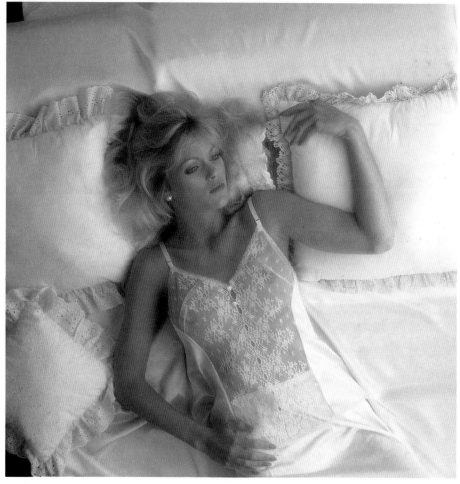

Type C

If your client has the following "Type C" characteristics, your client should wear a beige and gold-toned wardrobe. Ivory-toned lace suits this client very well. Shimmering gold evening wear is also just perfect. This client should avoid blue-reds. Golden reds are much better suited to the "Type C" woman.

The best makeup colors for "Type C" are earthy oranges or red on the lips, with dark peach blush.

Skin:
Ivory
Ivory with freckles
Peach
Golden beige
Dark beige
Golden brown

Hair:
Red
Red brown
Auburn
Golden brown
Red blonde
Charcoal brown
Black

Eyes:
Dark brown
Golden brown
Amber
Hazel with gold brown
Green with gold
Pale green
Olive green
Blue
Teal blue

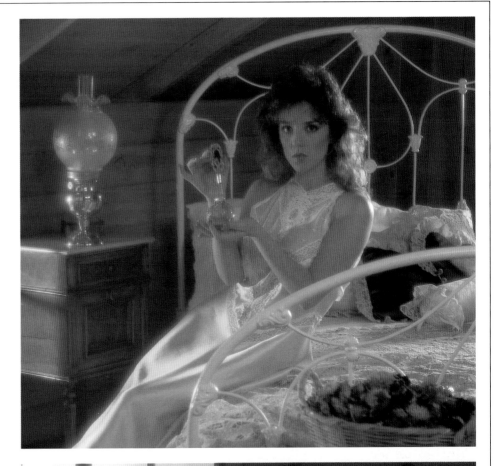

Type D

If your client has the following "Type D" characteristics, your client should wear a peach/pink or bright blue wardrobe. Coral peaches or pinks look the best on a "Type D" client, who should stay with warm-toned colors, and avoid icy or cool reds and blues.

Best makeup colors are light peach, coral or coral pink for lips, with peach blush.

Skin:
Creamy ivory
Ivory with gold
Peach
Peachy pink
Golden beige
Golden brown

Hair:
Yellow blonde
Strawberry blonde
Red blonde
Auburn
Golden brown
Cream white

Eyes:
Blue
Clear blue
Green
Clear green
Aqua blue
Golden brown

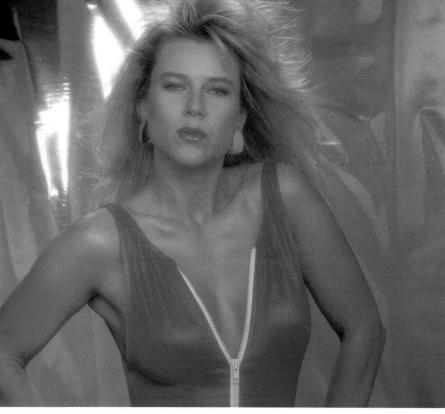

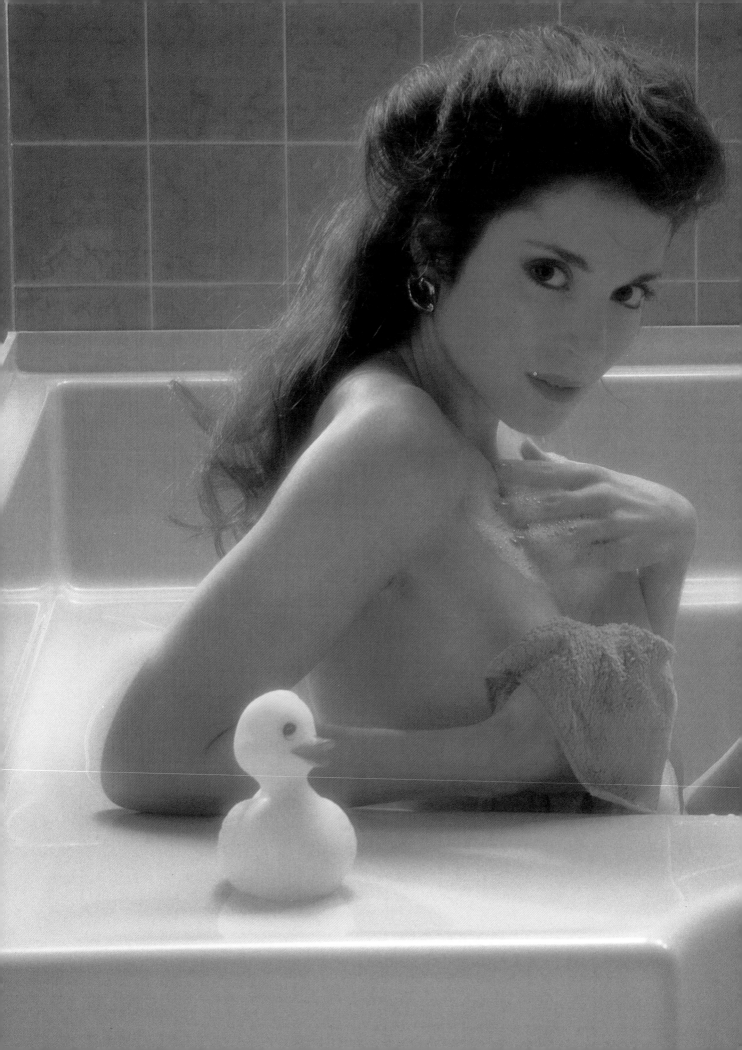

PART THREE

The Photo
Session

\mathcal{P}ROPER LIGHTING, a well-designed and propped set, quality makeup and good model direction are the elements all successful boudoir photo sessions must have. You will have worked hard to create the theme and set. You've sold a session to a potential client, and hired a stylist. Now comes the time to orchestrate a successful session.

One of the challenges you'll most likely encounter will be the nervousness of your client. She will feel better after she begins to feel confident and comfortable with you and your crew. We have been shooting for a very long time, and yet we, too, get nervous before a session. You will learn that the more skilled and prepared you are, the less anxious you will become.

Gently remind the client that this session is being done for fun! Also reinforce the fact that her confidence will increase after she finishes the makeover, during which when she can just relax and feel as pampered as if she were in a beauty salon.

As your client goes through her makeover, you will be reviewing wardrobe, lighting, and props. Don't forget to check in with your client and stylist from time to time, offering them refreshments and checking on the progress of the makeover. As the photographer, you must take complete charge of the session at all times, overseeing everything that takes place. Often we hear photographers complain that a stylist "over"-applied the makeup to a model, for instance, but our feeling is that the photographer should never allow a stylist to overdo the makeup.

The use of mini-blinds and a black leather couch adds a dramatic dimension to this boudoir set.

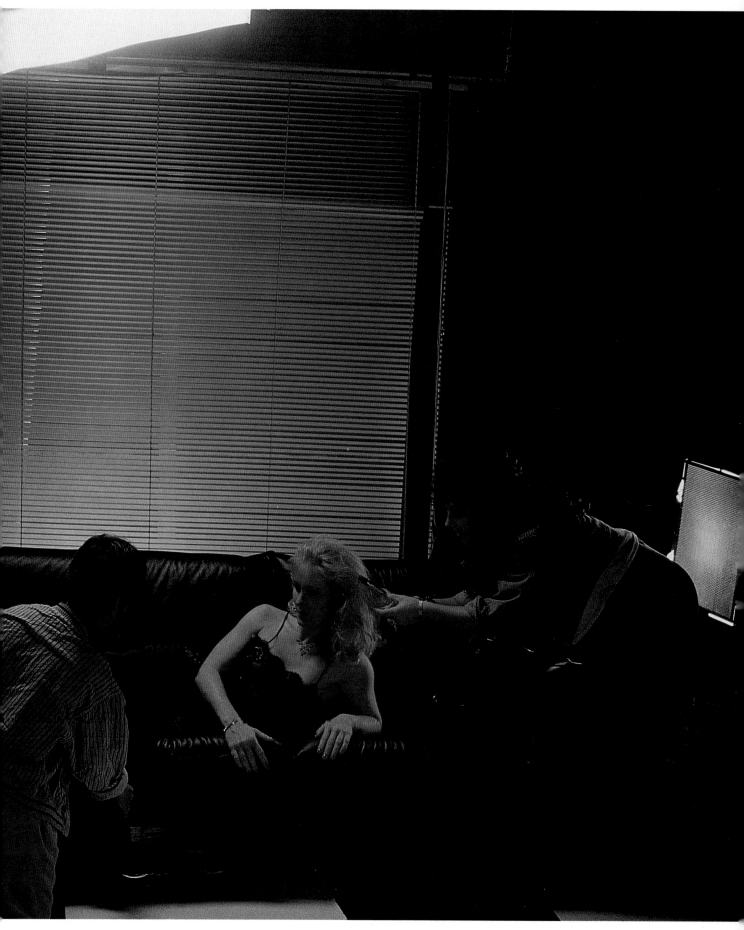

Simple Sets

We love a simple set, one that places an elegant focus on the model. Simplicity can be stunning. Remember the classic shots of Marilyn Monroe on simple white sheets? Another wonderful thing about a simple set is how easily you can incorporate it into your catalog of sets for boudoir photography, and thereby increase your business.

When we started to branch out into the business of boudoir photography, our first purchase was a simple brass bed. We then began to experiment with creating different looks around that same bed, which we created by switching camera angles. We love shooting straight down on a subject, which results in a simple, refreshing look. Three-quarter views are also favorite camera angles of ours. You seem to capture a certain innocence when you shoot down from this angle. We discovered that variety with a simple set can be achieved by adding different colored gels, or just changing the model's expression and/or camera proximity. The elements of a simple set can vary greatly but basically involve an easy-to-create background and some basic props. Simple boudoir environments might include a bed set, a vanity set, a chaise lounge, or a sofa. Sometimes even just backgrounds of satin

sheets, Levelor window blinds, comforters, or large folding fans are sufficient. The idea is to keep the set uncluttered and inexpensive, yet tasteful. These sets can be just as beautiful and effective as more complex sets. It's all in how you light it. The three keys to successful work are: "Lighting, lighting, lighting!"

Before you make the financial investment of acquiring a set, consider not only its price, but also its versatility and photogenic possibilities. Watch out for backgrounds that are too distracting or busy. For example, some wallpapers are too overpowering, and therefore distract from the true subject matter, your client. Make sure that, if you are putting together a period piece, for example a 1950s set, you fit into the correct time period with your background and props. But before rushing into buying expensive props and backgrounds, remember to consider an item's versatility and photogenic possibilities.

If you have trouble matching your furniture with your backgrounds, try consulting interior design magazines. They can serve as great sources for mixing everything from colors to furniture looks and trends. They will also run special stories on

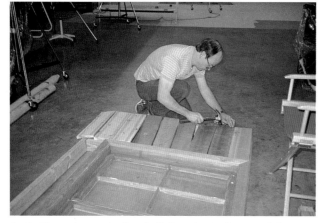

A studio assistant begins building the background that will be used for both the bathtub and bedroom sets.

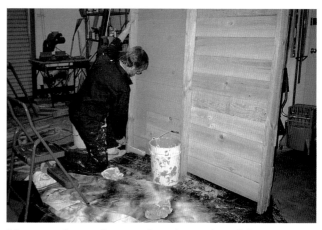

Next, another assistant paints the section of the background that will become the sloped "ceiling."

The paint job is finished, and the lower half of the set is fully assembled and in place.

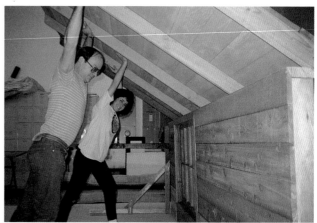

Two assistants support the "ceiling" while it is secured in the proper position.

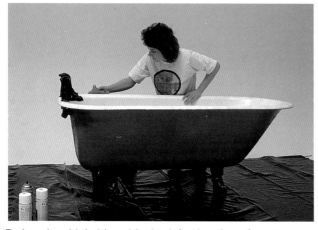

Before the old-fashioned bathtub is placed on the set, an assistant paints it, changing the color from a dark red to a bright white.

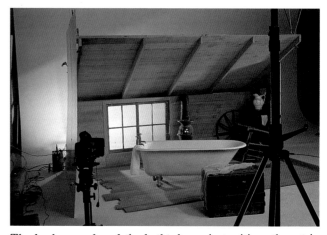

The background and the bathtub are in position: the set is ready for the shoot.

the restoration of homes in a certain time period, which can help with sets ranging from Victorian to Art Deco.

Whether a set is simple or complex, there are some basic ways to arrange it for added depth and drama. While you are setting up a set for a client, think of it in terms of foreground, middleground, and background. What is the background—a wall, a shadow, foliage? What is in the middleground— the subject, a bathtub, a table? Thinking in terms of the foreground, middleground, and background will help add dimension to a photograph.

Simple, effective backgrounds are easily created with what photographers call "seamless," or my-lar. Seamless consists of rolls of wide, heavy-weight paper dyed in as many as fifty different colors. Mylar is a shiny foil-based material available in 52″-wide rolls, in gold, silver, and primary colors. If you require a real "wall," use a light-weight piece of particle board; cut and paint it, and then support it with braces.

Be careful, when shooting a client against a "limbo" background—otherwise known as a "background cove"—with no reference point or furniture, that you create some sort of a reference point, to avoid producing the illusion that your client is floating in the air. This effect can be prevented by lighting your subject in such a way that a floor or wall can be sensed by the viewer. Any professional camera store sells seamless and my-lar. We suggest you stay away from hard, over-powering colors in either.

The importance of constructing well-conceived and well-built sets cannot be stressed enough. All of our sets are well built, and they all can be broken down for maximum storage capacity. Even if your sets are simple, they should be well made. Not only will the quality be perceived by your client, it will translate into the final product, your photos. Well-built sets are also safer.

On the subject of safety, don't forget to keep all power packs off the ground when photographing any sets containing a pool of water. If any water touches your power pack, you risk the danger of electrical shocks.

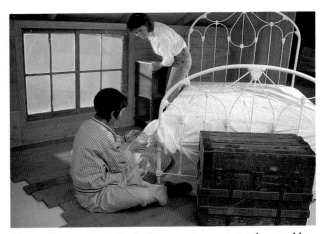

The stylists prepare the bedroom set: one puts the marble-topped nightstand near the window, and the other attaches lace to the bed linens.

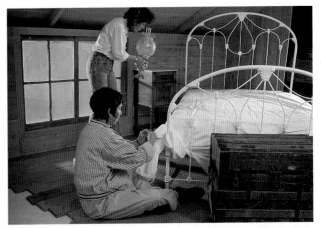

Here, the stylists continue the set decoration, adjusting the lace and placing an ornate lamp on the night table, which complements the white bed frame perfectly.

With the finishing touches added, the charming bedroom set is complete. It is a favorite among our clients.

SOME EASY-TO-PRODUCE THEMES

As a photographer, you should never cease to become inspired for a shoot by noticing your surroundings. To us, the very essence of photography includes the conceptualization of a set. We are very fond of working with "themes," and we look for their elements all around us.

Colorful folding fans. We have always admired the large folding fans we've seen in display windows. One day, while shopping, we happened to stumble across some lovely fans that were available in multiple colors. At the time we knew only that they would eventually make great props or a dynamic background. As it turned out, the fans became a perfectly simple and graphic set. As a background they provide a great tropical feeling without becoming too much of a cliché. The colors of the fans provide our guidelines for the wardrobe, makeup, and flowers.

The look and feel of the tropics are evident on this model's face and hair. The bright colors of her outfit and the fans behind her work well together.

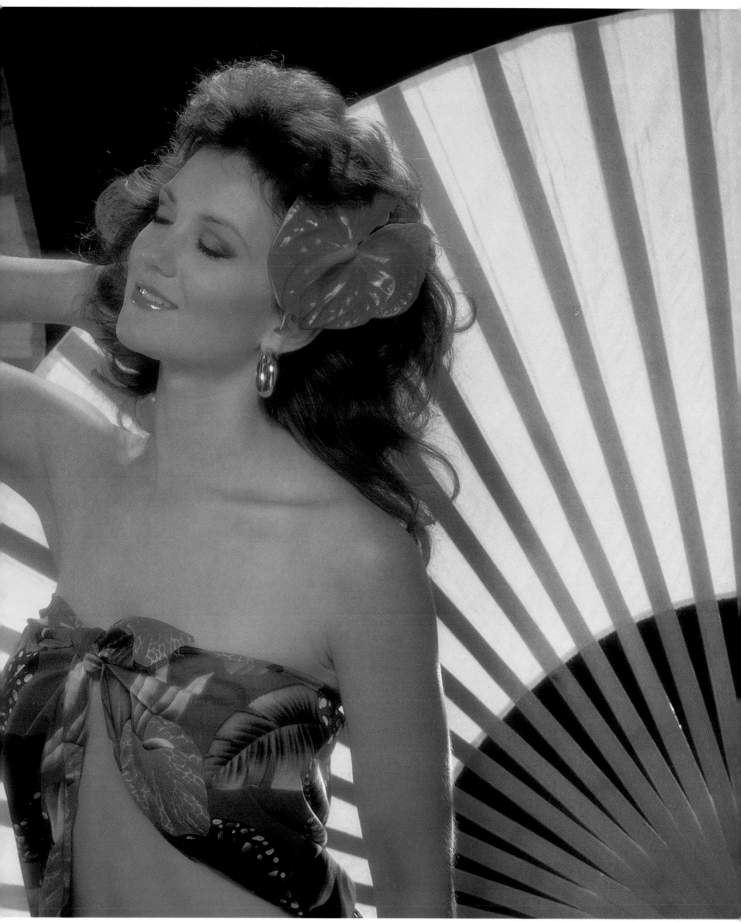

Simple Sets

Venetian window blinds. Another of our favorite sets is easily assembled with a black sofa and Levelor blinds. Putting a purple seamless background behind the blinds creates a very contemporary environment with the look of nighttime. Even with a simple set you can create an expensive-looking high-end result. Adding a glass of champagne can be the finishing touch. Of course, planning ahead with a model's wardrobe ties the whole set together. This particular set works well with blonde clients because the contrast of their hair against the black couch is so striking.

Silhouette lighting is dramatic and sexy. It outlines every curve on a subject's body, and adds a sense of mystery to the viewer. However, you must be very careful when undertaking a black set with a subject wearing black lingerie. The lighting must separate the wardrobe from the background. Remember to always light for detail when shooting with black. Although shooting through the blinds alone seems to be a very simple setup, it takes quite an extraordinary client to handle this set. It is very difficult for an inexperienced model to stand in high heels without a way to brace herself. We might suggest the addition of a chair or other suitable prop. When helping a client choose her set, be aware that not every figure is flattered when photographed behind a Levelor set. For this, your client should not be overweight, and the taller she is, the better.

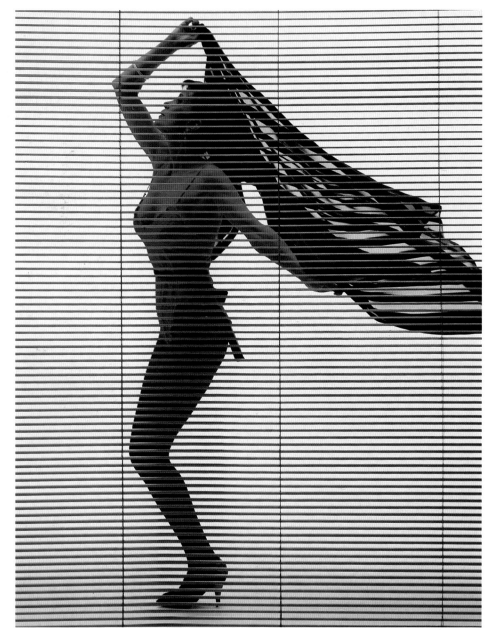

For the photograph at left, we positioned the client behind mini-blinds, gave her a sheer robe to hold, and turned on a fan. The flowing robe adds movement and provides a contrast to the static lines created by the blinds. The silhouette-like result was created by using four times as much light in the background than in the foreground. We found that this particular shot worked best when the woman's legs were placed side by side. The silhouette on the opposite page is also striking: the glowing torchere draws attention to the model's legs, which echo the shape of the saxophone.

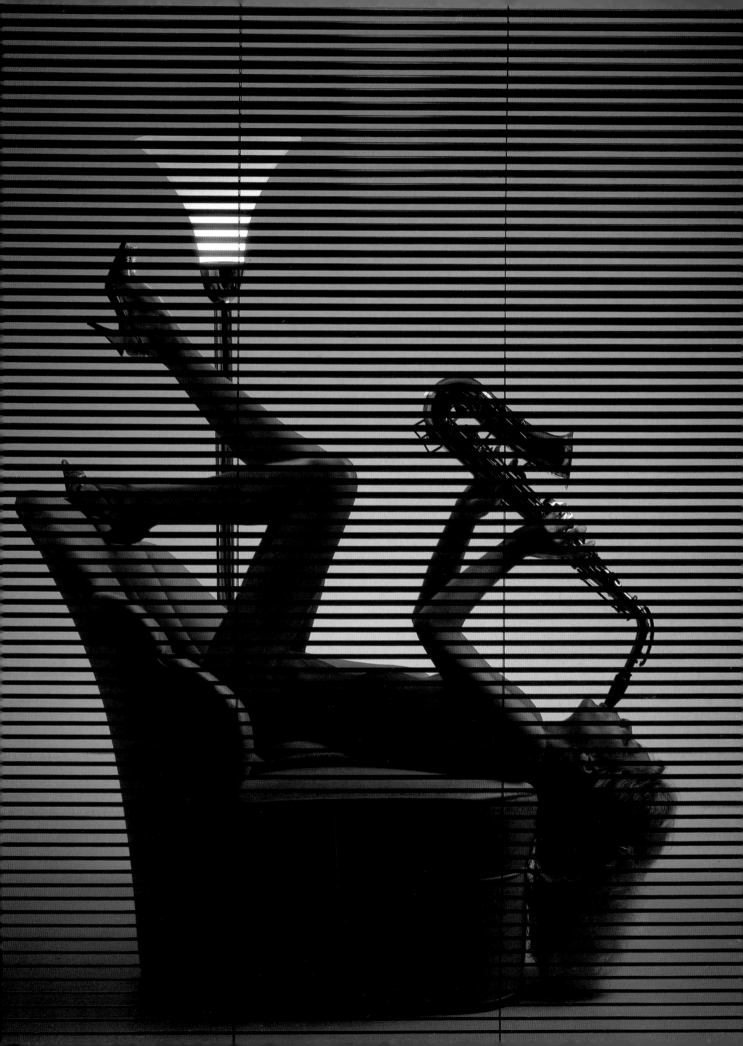

Vanity sets. The vanity looks like an extensive set, yet is fairly simple. With wallpaper, a mirror, dressing table, and chair, you can create a richly attractive set. There are many ways in which to work with your client in this set: show her putting on lipstick as she gazes into the mirror, combs her hair, lounges in the chair, or plays with a kitten.

A hand-held mirror or any other prop on the table gives something for your model to concentrate on while you are shooting. One of our favorite variations involves photographing the model while she is spraying on perfume. Old-fashioned spray bottles are fun and you can usually pick one up at a swap meet, flea market, or second-hand store. Remember, the more activities you create for your client to work with, the easier it will be to photograph her.

The chair itself in a set like this can be used as a wonderful prop. By moving the chair into different positions, you add even more dimension to the environment. Have the model straddle the chair, stand up and place one knee on it, or just lounge in it. Work with the chair and experiment with all angles. Although you will develop favorite poses, we find that, just when we think we have explored all the possibilities, new variations arise.

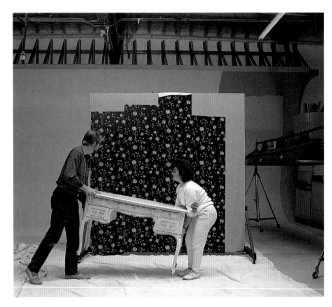

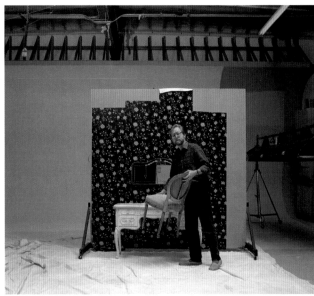

Basic Set Elements

- Simple wrought-iron bed or brass bed
- Chaise lounge
- Levelor blinds
- Sofa or couch
- Mosquito netting
- Satin sheets
- Vanity or dressing table
- Mirror
- Comforters
- Large folding fans
- Pillows
- Plants

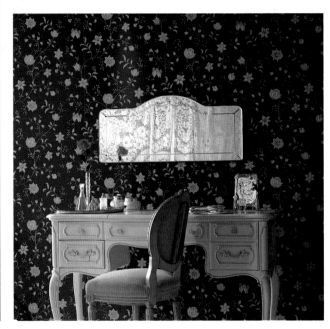

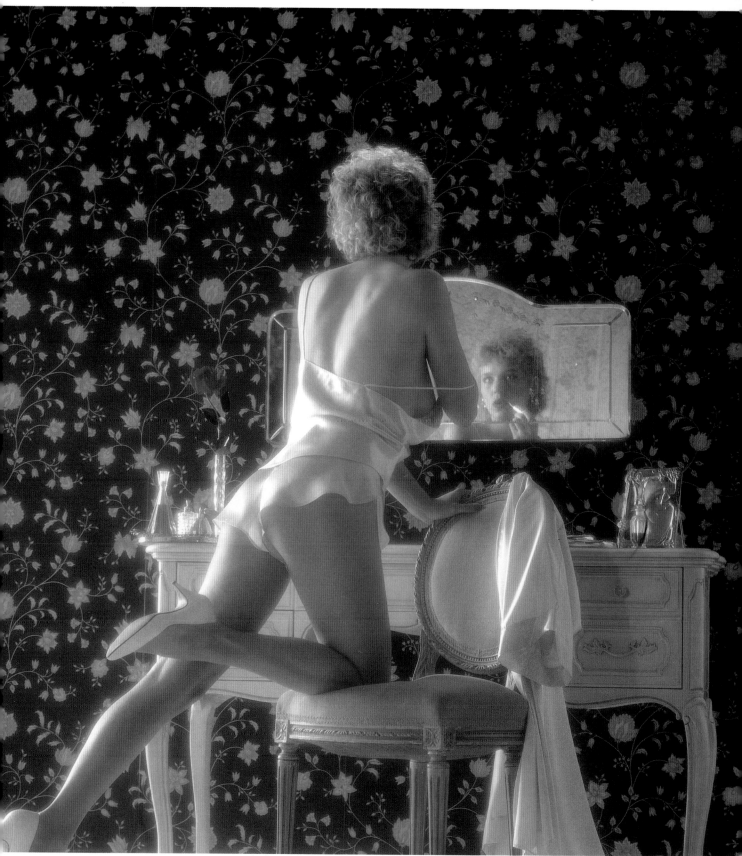

Dramatic lighting, a strong pose, and an intriguing reflection in the mirror combined to produce the beautiful, effective shot above. The creation of the vanity set is seen on the opposite page.

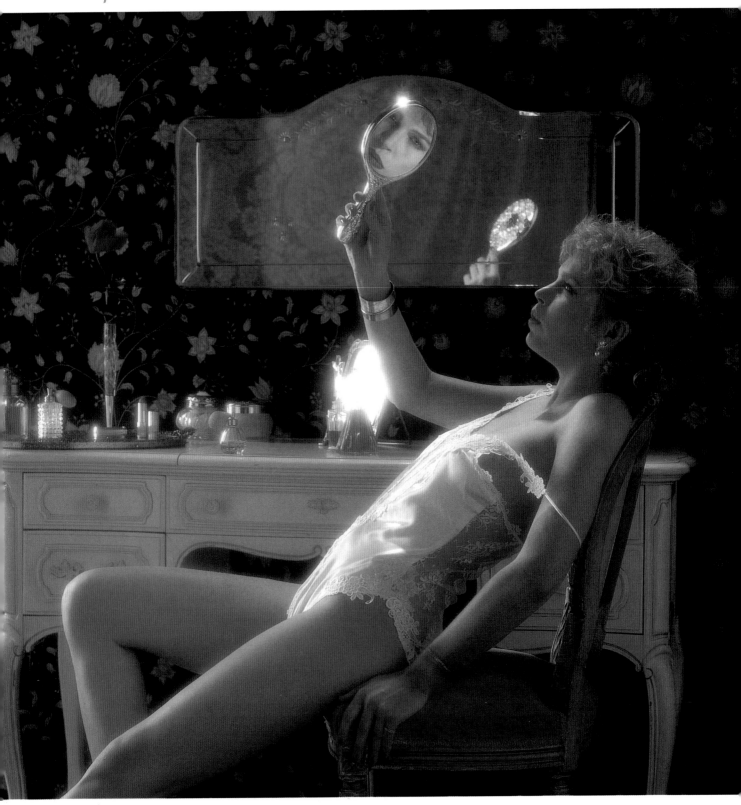

Our vanity set, complete with chair, perfume bottles, and hand mirror, allows us to position clients in a number of complimentary, dramatic ways. We decided to photograph this model in profile for a different look. Although she seems self-absorbed at first glance, her reflection in the small mirror and the fallen strap of her teddy are provocative.

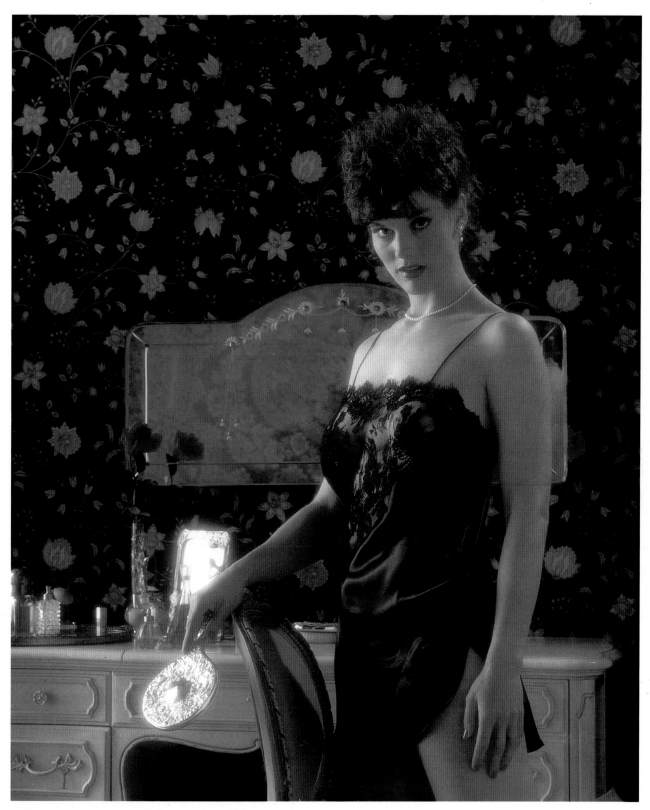

While photographing this client, we were struck by her
beautiful big eyes and decided to pose her looking directly
at the camera. We asked her to turn sideways and to place
her knee on the chair to create a complimentary line.

Props and Accessories

Props complete a set. They add that finishing touch that makes a shot both interesting and believable. Props fall into two categories: hand props, which are small hand-held items that range from a tube of lipstick to a book; and set props, or any other removable items from a set that are not intrinsic to its structure. Furniture is a good example of set props. Occasionally, a particular prop or article may take priority within a session. For example, we had a client who was given an expensive fur coat. It was very important to her that the coat be considered throughout her shoot. A fur coat is just an example of a special article that a client wanted to showcase, along with herself, during her session. You may want to consider obtaining a fake fur for your own catalog of props.

Hand props also add interest and involve viewers in photographs. The wonderful part of working with hand props is that they can occupy your client and distract her from any nervous feelings she may be having by allowing you to control the degree of camera awareness the model has. In other words, your model can be working with a hand prop and at the same time be looking directly into your lens, or you can have the model so involved with a prop

that she does not look toward the camera, thus creating a candid glimpse of your subject.

If you are showing your client spraying herself with a perfume bottle, make sure that you photograph a sequence of shots capturing moments just before she completes the action, during the action, and after the action has been completed. For example, show her about to dab the perfume, dabbing the perfume on her wrists or decolletage, and then pulling back from the perfume and, perhaps, looking directly into the camera. Have her slowly work through these movements so that you are able to capture the subtle changes in her actions. Talk her through the motions; she will be looking to you for direction and guidance. This technique of slowly talking your client through action with hand props will also make you feel more in control of the session.

Working with props requires taking precautions. Watch out for indistinguishable items within your photo. For example, some stuffed animals will not shoot well. They can end up looking like furry blobs! Check your advance Polaroid from corner to corner, and look for distracting items. Be careful not to waste props. If you shoot with a full-length

mirror, for instance, and there is nothing of interest reflected in it, you may be using up valuable subject space. Most important, don't let the props detract from your model.

Props can be procured in a number of ways. There are prop houses that specialize in renting props, and many retail stores are more than happy to set up rental arrangements with photographers on a regular basis. Another good way to obtain props is to visit garage sales, antique stores, and thrift shops. Sometimes you can find incredible deals on very useful and beautiful props. The key is to keep your eyes open.

One way to formulate your own stock of props is to review your own used and worn possessions. Use some imagination. Can you possibly paint these objects different colors? You can also decide to set aside money specifically for one major prop at a time. Each time you shoot a client, perhaps you could save $25 toward your goal, which is how we saved for the bank of lockers we purchased through a used-school-supply dealer. After a new coat of paint, we had our lockers.

Before launching into buying sets or props, poll your clients to test the concepts of a set first. If you under-prop a set, your final shot may look sparse and incomplete. If you over-prop it, chances are you will clutter the set and distract from the most important element in the shot: your model. If you choose simplicity on a set, be sure you move in closer on your model.

Boudoir Hand Props

- Various perfume bottles
- Mirror and brush sets
- Several champagne glasses
- Old-fashioned telephone
- Several attractive lipstick containers (to be used only as props)
- Holiday accessories (i.e.: heart-shaped pillow or Santa's hat)
- Framed mirrors
- Letter opener
- Framed photos
- Vanity dressings (i.e.: crystal cotton ball holder, atomizers, cosmetic bottles)
- Decorative boxes
- Candlestick holders or candlesticks
- Novels or old leather-bound books
- Clocks
- Vanity tray
- Bud vase
- Teapot
- Colored hand towels and washcloths
- Masks
- Lamps
- Assorted pillows

Keep your props well organized for easy access during a photo session. There is nothing more frustrating than stopping the flow of a session by searching for a hand prop.

Remember that using props can really add another dimension to boudoir photography. For example, simply adding a brass coatrack to a bathtub setup would let you display some lovely lingerie belonging to the client. Sponges, yellow ducks, and back brushes, all fun props to play with, would give your model something to focus on and help you achieve spontaneous and comfortable reactions from her. Any photography session will benefit from the inclusion of a few carefully chosen, attractive props.

These are a few of our favorite and most useful props. All are especially helpful: they give nervous models something to interact with.

Use your imagination when selecting props. We were lucky enough to have six kittens around the studio shortly before Valentine's Day. They looked darling in almost every shot, and the model's playful expression as she holds this kitten makes this image bright and cheerful.

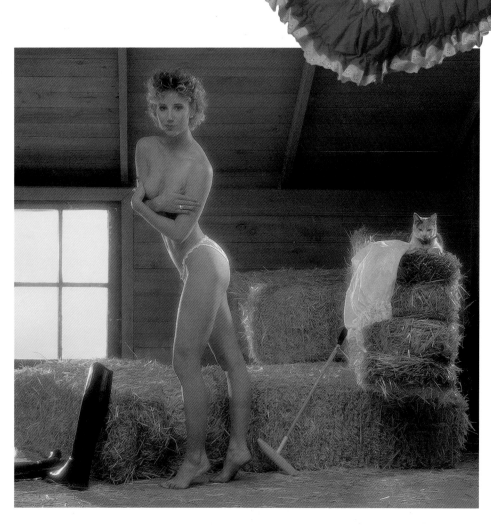

Clients always look sexy and alluring in seminude shots. The polo props and accessories immediately set the mood for this picture; we used them because the client told us that her husband has an avid interest in the sport.

88

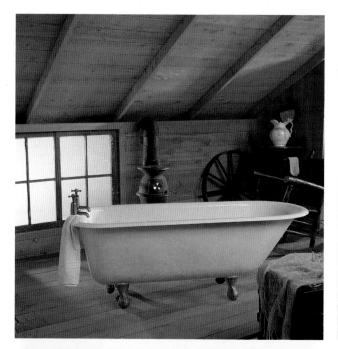

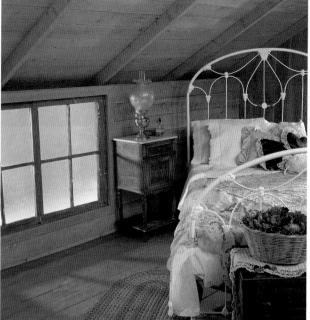

Carefully propped sets like these will look interesting and inviting even when no one is on them.

Posing the Model

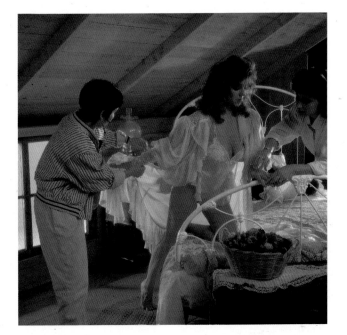

Posing or placing a client correctly within a set is critical for creating a special mood or flattering a figure. Your subject's body must convey a sense of confidence and purpose, and she needs to remain calm and at ease, so that your work looks natural. Once a flattering body pose has been achieved, you can then concentrate on capturing small, subtle changes in facial expression. After the correct pose is struck, it is necessary to have the model tilt and move *only* her head. Make sure posing isn't too stiff-looking or "posed" in its feeling. If you would like to achieve a more natural facial expression, have your model look away and then, on the count of three, look back toward the camera. This will give you a more spontaneous expression. And feel free to have her look away from the camera, which is a nice alternative to the model's always making eye contact with the lens. It also achieves the feeling of a very candid portrait.

There are many ways to de-emphasize a figure flaw and accentuate a figure asset. Crossing one leg over another while turning the model's hip to the camera will slim heavy thighs. Partially covering a figure can work, as long as you still show some portion of the body. Be very careful when shooting against a dark or black background. You can sometimes completely "lose" a body this way, since it may create the illusion of floating or detached body parts. The accompanying chart will give you some good strategies for solving figure problems. One of the simplest is to play up your client's attractive features.

Don't ever place clients in an awkward pose. It is sometimes easy to place them in poses that are attractive for the camera but uncomfortable to hold for any length of time. Get into the habit of asking your client if she is truly comfortable holding a pose. Lying a model on her side in a bed scene, for example, can become very uncomfortable after a short period. When working with this pose, if you cross one of her legs over the other, be careful not to "fatten" the top leg by pressing it hard against the lower leg. This will spread out the upper thigh and make it look heavier.

The key here is to lengthen the legs. Do not have your client bend her knees drastically toward camera or pose a woman by placing her on her knees with her thighs resting on her calves. This pose enlarges the thighs as they press outward against the calves.

Be conscientious about awkwardness. Don't let elbows and body parts sink too far into pillows. While you don't have to show everything in a photo, you don't want to exaggerate the problems you are trying to conceal. You can achieve a superior look in any shot by preventing your model from locking a joint or limb. Always keep her elbows and knees slightly bent. Avoid pressing a woman's arm against her body when that arm is facing camera. This expands the arm and makes it look heavier. One standard trick for enlarging a woman's bustline while she is not lying down in a pose is to place one shoulder toward the camera while the arm away from the camera is used to press against the side of her breast, but avoid pressing the arm that is facing the camera.

Look for unusual bends and twists with wrists, ankles, and neck positions. Fingers and hands can become strained and stiff, if you're not careful. Fingers should be "gently touching" something all of the time. Pressing too hard causes tension in hands and veins protrude. Whether they are touching a garter or a thigh, fingers should barely touch. Pointed toes—with, of course, clean feet—add a

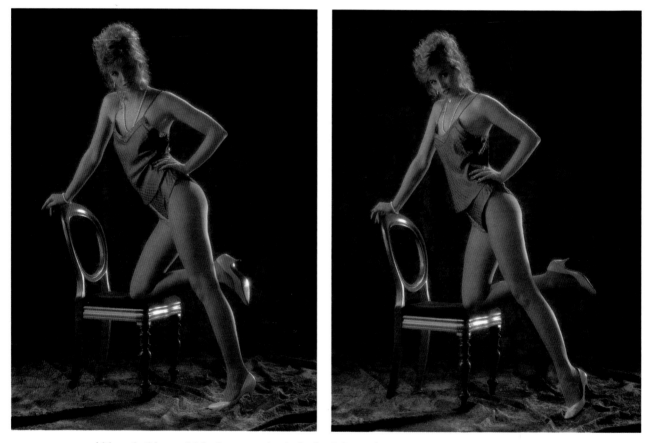

Although this model looks attractive in both of these pictures, the pose on the right is superior. Notice the elegant line of her straight leg, a result of having her point the foot of her bent leg. Also, the tilt of the model's head is more flattering than the awkward angle in the shot on the left.

longer, more flattering line. And keep an eye out for red marks left by tight clothing, elastic, or wristwatches.

Older clients require some special consideration. Advise a mature client to look for an elegant, flattering wardrobe. She should avoid youthful cuts and styles unless her personality is specifically suited for current trends. Never place an older woman in an extremely contrasty set, because it will emphasize wrinkles. Avoid photographing her with black props, wardrobe, or backgrounds, whenever possible. Soft tones, diffusion, and high-key lighting are more appropriate for an older woman's session.

Samples of good posing are all around you. Pick up any magazine and start to use tear sheets as guides for your own work. Show your clients the poses you want them to work on. Add your own variations, if you like, but we cannot over-emphasize the importance of using tear sheets for inspiration and to demonstrate posing techniques to models. Despite our experience, we always keep a variety of tear sheets on hand at the studio for posing ideas.

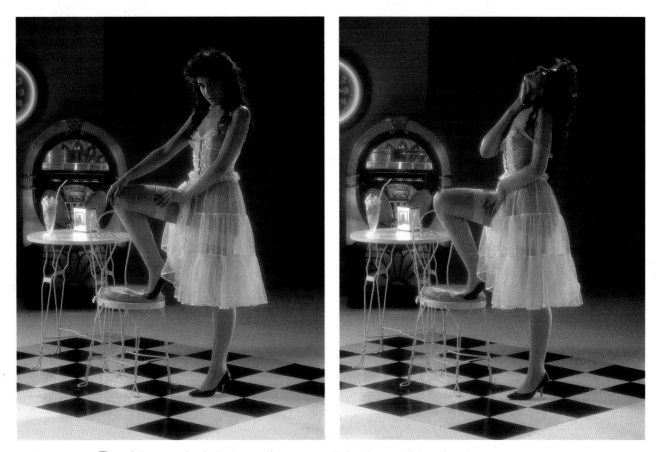

Two of the most basic but appealing poses call for the model to adjust her garter or stocking or to tilt her head back and stroke her neck. The resulting images are always sensational. In the photograph on the left, the model appears alluring and confident. Moments later, for the shot on the right, we wanted an even more seductive look and suggested this pose. With practice, photographers can become adept at posing clients and talking them through a shoot.

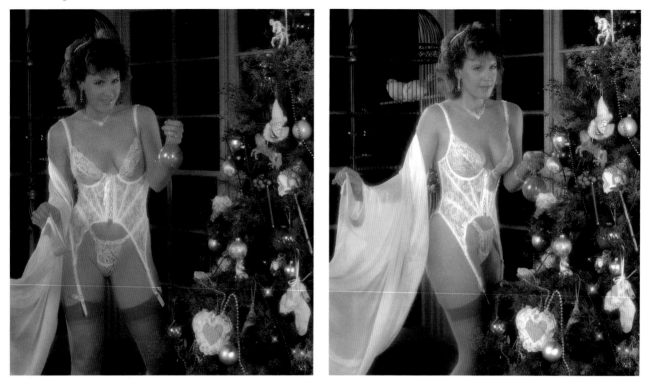

Crossing a model's legs properly in a photograph, as in the shot on the right, can make her seem slimmer. With the front of her legs directly facing the camera, this client appears to have heavy legs in the picture on the left. Photographs in which the model is at an angle to the camera are more complimentary.

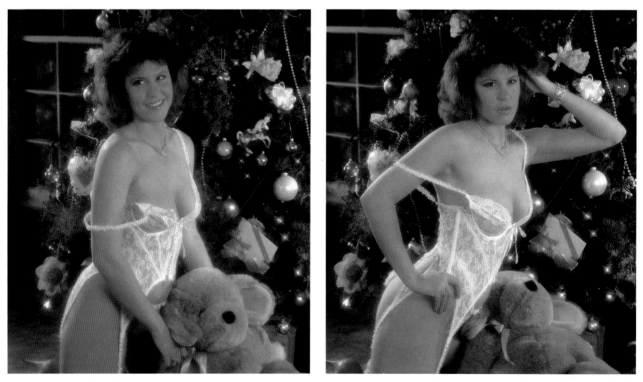

It is important to try to capture a range of emotions during a session. Start by making the model feel comfortable and secure. Then, after you gain her trust, she should be able to strike a variety of poses. This model found it easy to make the transition from looking sweet in the shot on the left to looking sensual in the shot on the right.

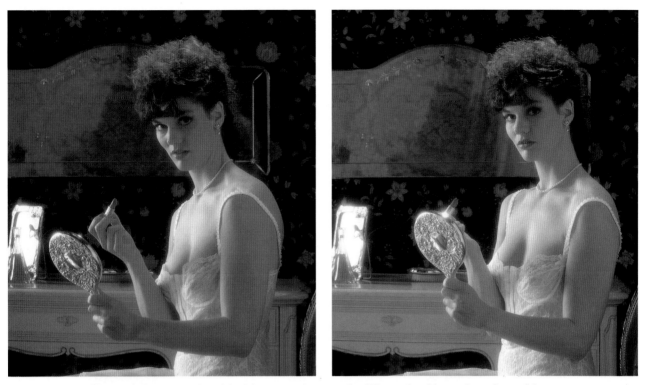

The model's posture is critical in every photograph. Clients should stand or sit straight and not round their shoulders. This model looks much better—and more comfortable—in the picture on the right, in which she sits erect with her shoulders back, than she does in the shot on the left; there, her shoulders are hunched in an awkward position, making her appear stiff. A flattering neckline can be obtained by simply adjusting a slouching shoulder.

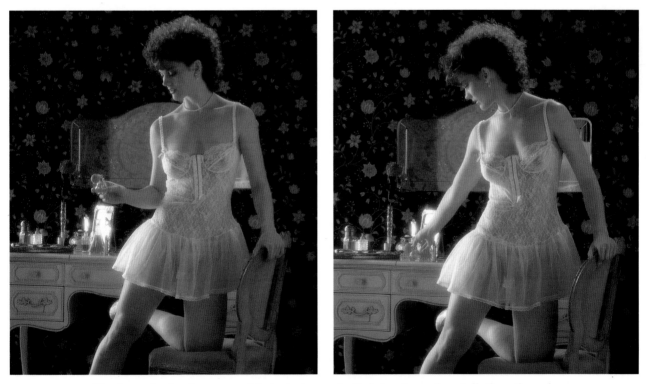

We always try to give our models props to occupy their hands, and we talk them through various movements. In these pictures, the use of a perfume bottle enabled us to photograph the client in poses that suggest a total lack of camera awareness. Both images are effective and flattering.

Making a few minor adjustments can greatly improve the way a client appears. In the photograph on the left, the model seems to be looking at something directly in front of her, and the strap on her teddy is in place. For the shot on the right, we asked her to glance downward, and we lowered the strap. The result: the client looks more provocative and alluring.

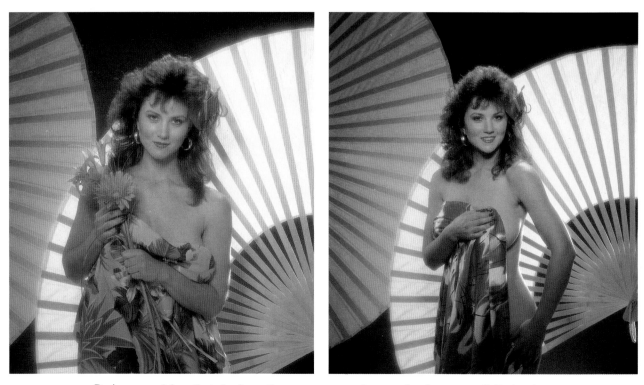

Posing a model so that she faces the camera squarely can often be very unflattering to her, as in the picture on the left. By turning the client's shoulders away from the camera and selecting a more complimentary wrap, we were able to significantly improve this pose; the result is on the right.

When working with a client on a set with running water, make sure that you photograph her with dry hair at the beginning of the session (left photograph). Once a client's hair and makeup become wet (right photograph), it is difficult and time-consuming to retouch them. Also, before the shoot, notify your makeup artist that waterproof makeup is necessary.

During a session, it is necessary to determine a client's best features and to play them up. In the photograph on the left, this model's lovely red hair is displayed prominently, while the shot on the right shows off her stunning legs.

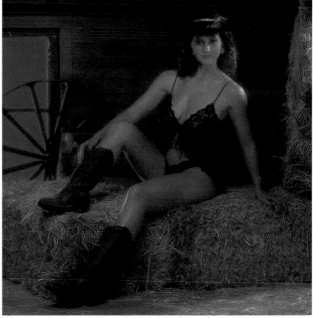

When we want a new, fresh expression, we ask the model to look away from the camera, as in the picture above, and then on the count of three, to look back. This technique eliminates frozen or forced expressions.

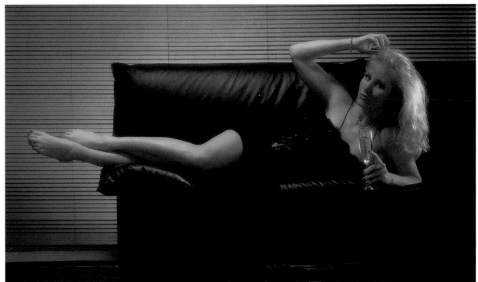

Subtle changes in a model's pose can improve a shot dramatically. Everything in the top photograph looks perfect—except for the client's hand position. She seems uncomfortable, and the running of her fingers through her hair seems forced. In the bottom photograph, the model seems more relaxed and her hand position more natural—the result of gentle coaxing.

You can correct many figure flaws with the right wardrobe, lighting, posing and cropping. The following are a few hints in handling figure problems.

■ **Wide Hips and Thighs:**

Turn hip toward camera.

Use fabric along the back of thigh, if possible. The fabric can be used whether the model is lying down or standing.

Creatively crop the photo into the thigh area.

■ **Large Chest:**

Do not place client flat on her back.

A well-fitted wardrobe with support wire can prevent sagging.

Camouflage by bringing bed linen up and around chest area.

■ **Small Chest:**

Shade in cleavage area with blush.

Special bras are available to push up a small chest.

■ **Thin Legs:**

Use fuller cuts of lingerie around the thigh area.

Cross legs at the thigh to broaden thigh area.

■ **Heavy Model:**

Camouflage with bed dressings or tub set.

Avoid having client stand up in the set.

■ **Very Thin Model:**

Avoid skin-tight clothing. Use fuller ruffles on teddies or lacy fringe on corsets.

Remember to apply horizontal wardrobe lines to a thin figure, while a heavy figure uses vertical clothing lines.

■ **Pear-Shaped Figure:**

Use wardrobe to broaden chest and shoulder area. Fluffy boas or sleeves help to proportion the top and bottom of a figure.

■ **Short Model:**

Use high heels and have client point toes.

Avoid having client stand up in the set.

Select sets that work well with short clients. For example, do not place a short client in the Levelor or shower set, unless your client is thin and well-proportioned.

■ **Very Tall Model:**

Take advantage of long legs or other assets.

Watch for the scale of your set. Do not use a very small or short bed with a tall woman, for example.

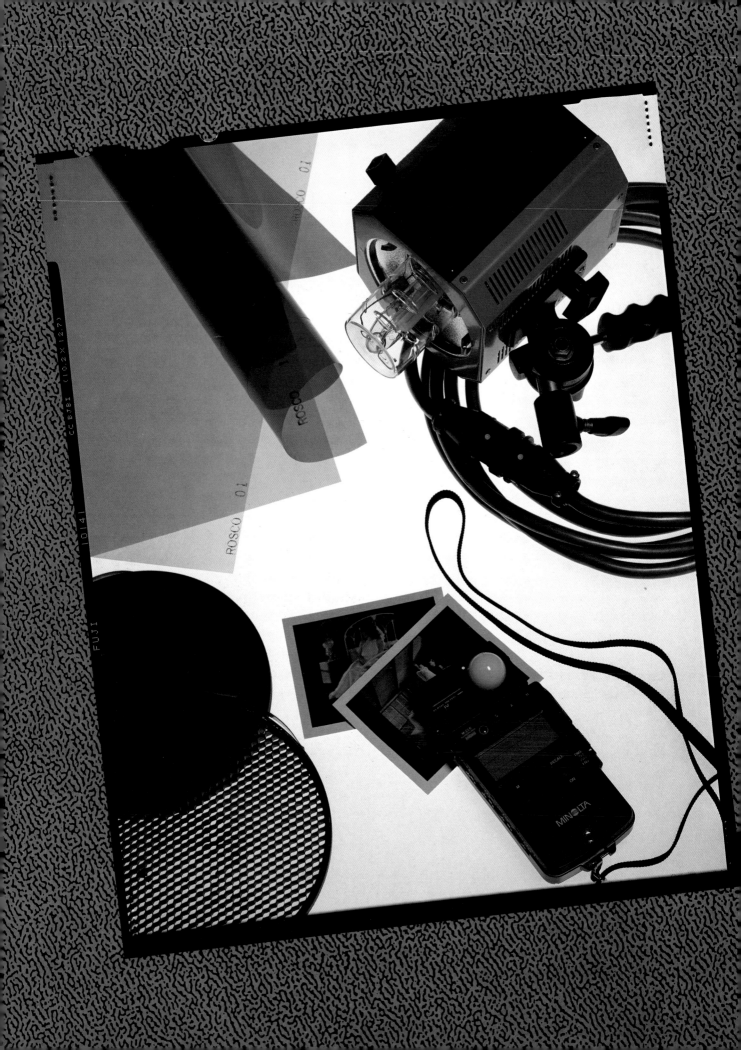

Lighting Techniques

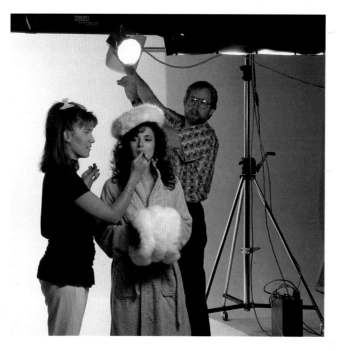

Quality lighting is a very important element in all boudoir photographs, and essential to capturing a client at her best. There is no *one* right way to light someone in a given situation, but there are countless *wrong* ways. The most important guideline we can offer you is to *visualize precisely what a light is going to do before you turn it on.* What quality of light are you trying to achieve? Is it hard and severe, or soft, playful, and warm? What time of the day or evening do you want to portray, and how can you do that? Is the light rich with color, or neutral?

In order for you to work quickly and efficiently, these and other lighting questions need to be considered *before* the photo session begins. Nothing destroys a photo session faster than the subject losing confidence in the photographer because he or she is obviously struggling with the lighting! Learn to visualize your final result in your mind. Once you can do that, the rest is easy. Make notes and a sketch of what you are trying to achieve. Block out your lighting using that information and the above questions, (refer to the lighting diagrams throughout this book for specific examples). Becoming efficient at this takes consistent practice.

The sets are in place, the lights have been positioned, and preliminary Polaroids have been completed before the model comes on the set. Once the model is ready, you can position her in a comfortable pose and begin final lighting. The light to start with is the one that will be the most dominant in the finished shot. This may be the light illuminating your subject, but often the dominant light is the light that gives the overall background illumination, and has little influence on the model lighting. This main, or key, light frequently requires a color gel over it to create a mood representing warm, early morning light or cool evening light. Once you have determined the proper placement and output of this main light, the balance of the lighting is done in relationship to it.

After the proper exposure for the main light is determined, the next light to position is the back or side light that acts as an edge light defining the model's edges and giving depth and dimension to the situation. This light, principally responsible for defining her body and keeping the overall lighting from looking too flat, should be adjusted in distance or output until it yields a Polaroid in harmony with the main or key light.

After the main and side lights are properly adjusted, it is now time to work with the subject fill light. This light, or fill card, is used to boost the shadow areas on the subject. If you only need a slight amount (½ stop or less), a fill card will do nicely. Anything more will require another strobe head. For our purposes we generally work with a fill light output of from ¾ to 1½ stops less light than the side light. If the output of this fill light is too close to that of the side light, your results will be flat.

The fourth light we usually work with is the hair light. This light adds emphasis to the subject's hair and helps separate her head and shoulders from the background. The output needed from this light varies greatly, depending upon the model's hair color and desired effect. Sometimes just a hint of light is all that is necessary. Other situations may call for output of at least that of the main light or up to a ½ stop more. On most occasions there is a grid spot over this light.

Now you are ready to shoot the first Polaroid that shows the fully lit set, model in place, in a good starting pose. Examine the following aspects in this Polaroid: Are all the lights doing what you want? Is the set over- or under-lit? Do you need another light somewhere on the model or background? Are there any hot spots to be removed from the forehead, shoulders, or hips? How is the composition of the shot? Are there enough or too many props in the shot? How is her body language? Does she appear relaxed, natural, and at ease? You may consider preparing a checklist of all the different things you want to watch for, until all of these questions become automatic.

If everything is looking right, take at least one more Polaroid, using your diffusion and warming filters in place over the lens, and make any final modifications on composition, propping, lighting, exposure, and pose. Eventually, you'll shoot a perfect Polaroid. Mark it as "final" and use it as the starting point for shooting film. Remember to match your lighting to your subject. If you are shooting a natural environment, try to maintain a natural kind of light. Avoid wild lighting, such as arbitrarily placed glows and splashes of color on walls and backgrounds. Watch harsh or monster lighting.* If you do not absolutely know what effect you are trying to create, don't experiment with clients. Practice on your time, not your clients'.

Lighting Summary

A typical boudoir set is illuminated with three to six different strobe heads, all with distinctly different functions:

- **The Main Light** sets the light level and mood for the overall shot.

- **The Fill Light** boosts detail in the shadow areas, and creates the appropriate contrast.

- **The Back or Side Light** gives definition and contour to your subject, and creates contrast in the shot.

- **The Hair Light** brings detail to the model's hair, and, appropriately used, brings a feeling of glamour to the shot.

*When you light a subject from above or below the face or head without properly "filling" in the face with bounce light or another light source, you can create harsh dark circles or pockets around the eyes, nose, and mouth of your subject. This effect can look scary or monstrous.

4' × 8' FLAT

WURLITZER

HAIR LIGHT

MAIN LIGHT
GALAXY BOX

TABLE

SIDE LIGHT

CAMERA FILL LIGHT PLB

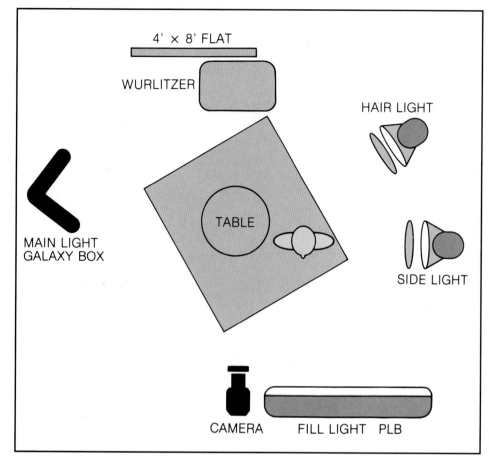

To accomplish this look, we first fired all the strobe heads for the initial exposure. Then, with only the clock and the Wurlitzer illuminated, we opened the shutter for approximately eight seconds. This gave us the desired "bleed" with the neon. We included the rim side light to highlight the model's figure. While the results are wonderful, time exposures are tricky and require the client to hold very still.

HAIR LIGHT

8'' × 8' ROLLING FLAT

MAIN
GALAXY
CLAMSHELL
LIGHT

VANITY

8'' × 8'
REFLECTOR

CURTAIN
REFLECTING IN
VANITY MIRROR

CAMERA

STROBE HEAD w/WARM GEL

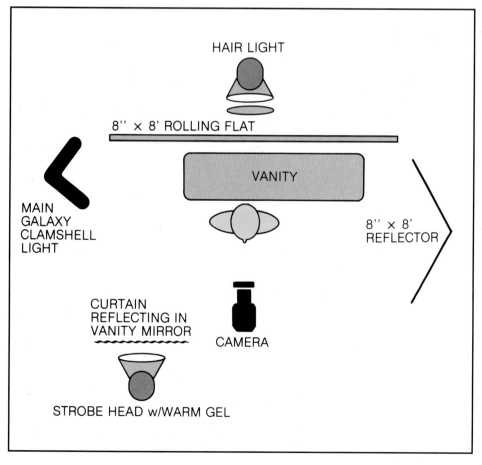

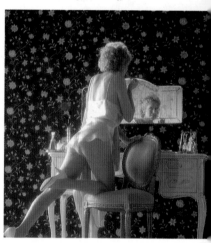

Here, we used a strobe head with a gel on it to create a nighttime mood. The main light and reflector provided the right amount of soft lighting needed. The finishing touch, a hair light, enhanced the mood. The translucent light coming through the curtain and reflecting in the vanity mirror was another special lighting element.

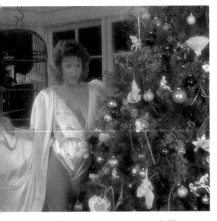

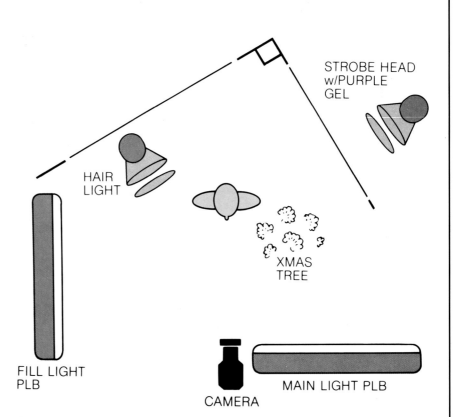

The key to successfully lighting this scene was using many light sources without overexposing it or overpowering the mood of the set. Gels carefully chosen and placed in front of the light sources helped to add drama. This shot was deliberately done at night so that we would be able to play with both the bluish purple light and the warm "fire" light falling on the subject. The tree lights created a holiday glow.

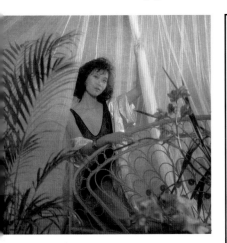

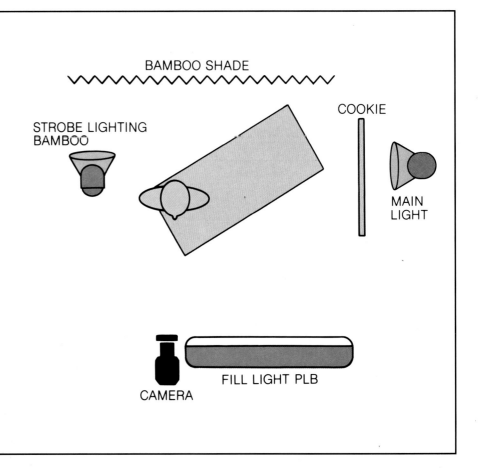

With this set, we wanted to achieve the illusion of natural sunlight streaming through the foliage. For a dappled light effect, we used a cookie in front of the main light. This broke up the light so that when it struck the model, it created subtle light and dark areas.

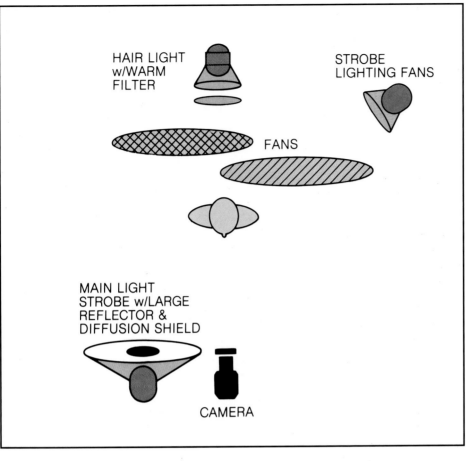

HAIR LIGHT
w/WARM
FILTER

STROBE
LIGHTING FANS

FANS

MAIN LIGHT
STROBE w/LARGE
REFLECTOR &
DIFFUSION SHIELD

CAMERA

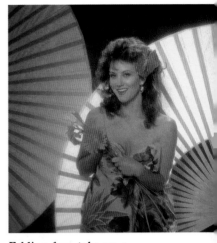

*Folding fans take on a
whole new glow when
strobe lights are placed be-
hind them. We also used a
main frontal light with a
diffusion shield, for a soft,
even overall cast, and a
hair light.*

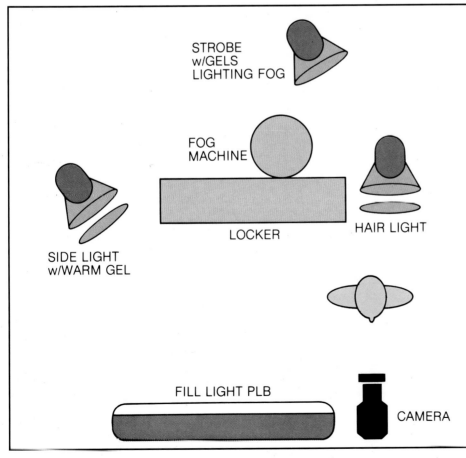

STROBE
w/GELS
LIGHTING FOG

FOG
MACHINE

HAIR LIGHT

LOCKER

SIDE LIGHT
w/WARM GEL

FILL LIGHT PLB

CAMERA

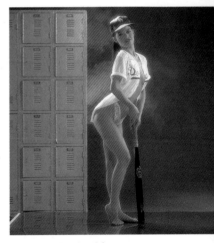

*To add color to this trans-
lucent fog, we used gels
over the rear light. The
model was illuminated by
the hair light, the side light
with warming gels, and the
PLB fill light. The results
are dramatic.*

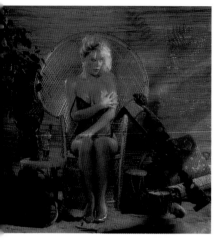

The main light positioned to the right of the model was strong and directional. The fill light to the left of the camera prevented a harsh look by softening the illumination.

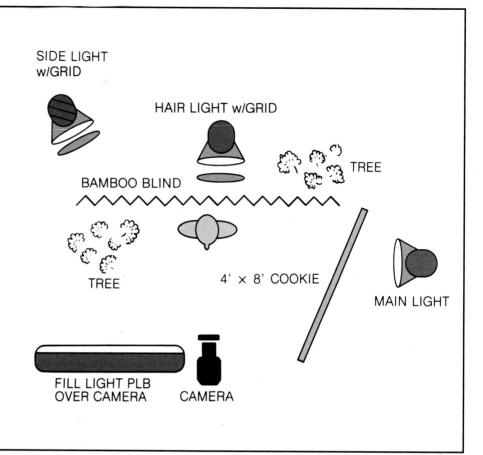

SIDE LIGHT w/GRID

HAIR LIGHT w/GRID

TREE

BAMBOO BLIND

TREE

4' × 8' COOKIE

MAIN LIGHT

FILL LIGHT PLB OVER CAMERA

CAMERA

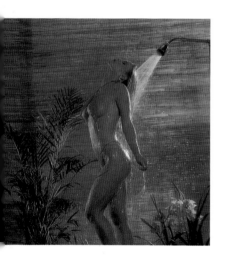

The hair and main lights were positioned at angles that would enable them to backlight the water, causing it to sparkle. Most transparent objects, such as water, windows, wine glasses, curtains, and sheer garments, should have light directed through them.

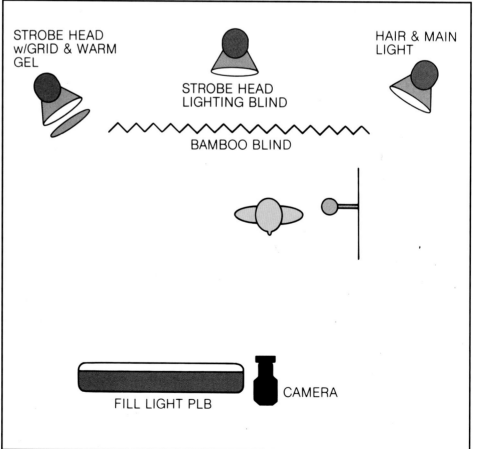

STROBE HEAD w/GRID & WARM GEL

STROBE HEAD LIGHTING BLIND

HAIR & MAIN LIGHT

BAMBOO BLIND

FILL LIGHT PLB

CAMERA

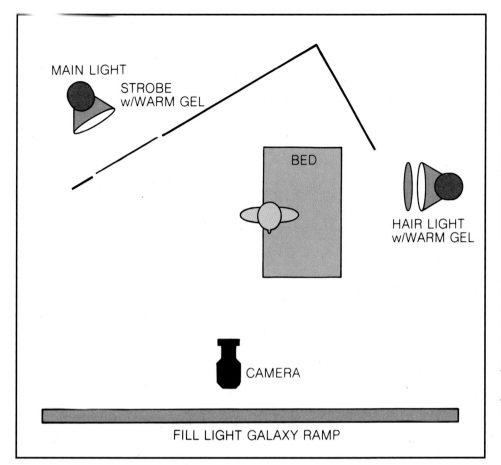

MAIN LIGHT
STROBE
w/WARM GEL

BED

HAIR LIGHT
w/WARM GEL

CAMERA

FILL LIGHT GALAXY RAMP

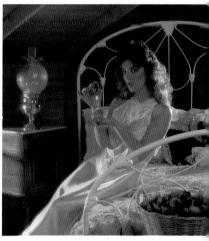

Because we illuminated this set with warm golden gels over the main light and hair lights, we used a galaxy ramp to fill in the rest of the bedroom set. This fill light was the perfect choice for soft, even lighting, which is the most flattering lighting for most women.

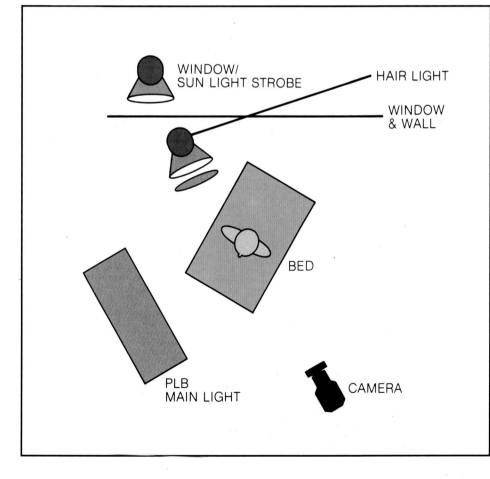

WINDOW/
SUN LIGHT STROBE

HAIR LIGHT

WINDOW
& WALL

BED

PLB
MAIN LIGHT

CAMERA

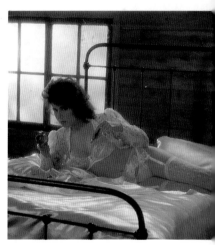

Specific set configurations greatly influence how particular sets should be illuminated. This bedroom set required us to place the window and hair lights behind the model so that they would shine lightly on her shoulder and backlight her hair. To minimize the harsh shadows that fell on the subject's face, we used a PLB as the main light.

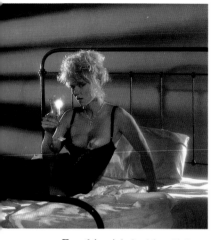

For this rich-looking lighting, we used a main light; a hair light, which is always a must; and a fill light. The spot light, covered with a gel, created the mood of this nighttime shot.

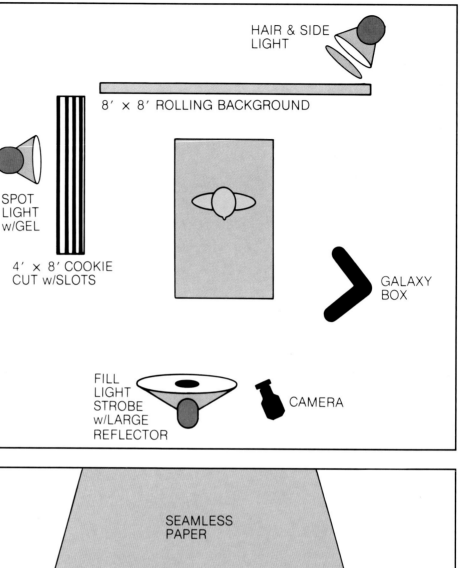

HAIR & SIDE LIGHT

8' × 8' ROLLING BACKGROUND

SPOT LIGHT w/GEL

4' × 8' COOKIE CUT w/SLOTS

GALAXY BOX

FILL LIGHT STROBE w/LARGE REFLECTOR

CAMERA

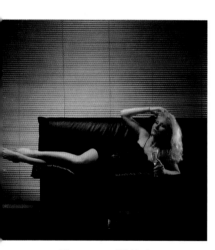

Here, two PLB boxes served as the main light sources and cross-illuminated the subject. We angled the spot light behind the leather sofa to illuminate the lavender seamless. While this setup was simple, it worked quite well on this set.

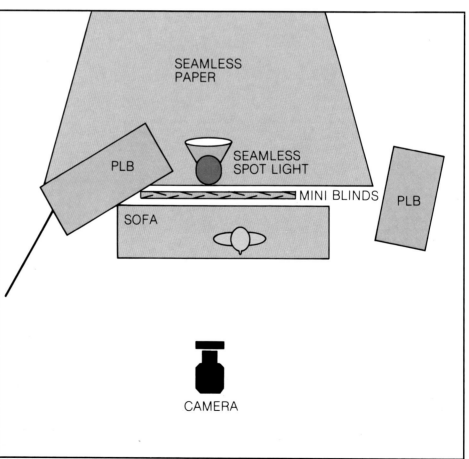

SEAMLESS PAPER

PLB

SEAMLESS SPOT LIGHT

MINI BLINDS

PLB

SOFA

CAMERA

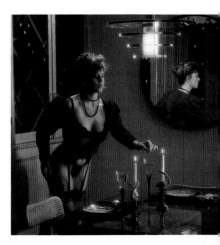

HAIR & SIDE LIGHT

CAMERA

FILL LIGHT PLB

For this shot, the main light was a simple lamp. We used a PLB fill light, as well as hair and side lights combined in one strobe. The dinner candles provided the fourth light source. The mirror on the wall added a certain amount of bounce light. When working with a mirror, you must tip or angle the mirror so that you are not reflected back onto the film plane.

In Summary

- Watch for backgrounds that are too distracting, and wallpapers that are disturbing or do not fit the correct time period or design sense of a set.

- Look through interior design magazines for inspiration and guidance.

- Make sure that your subject is not "floating" on your background, and that there are points of reference within your shot, especially if you are shooting on seamless paper or on a cove.

- Don't waste your time building shabby sets; sturdy sets save time and money in the long run.

- Are you using dimension and depth, including foreground, middleground, and background in your photograph?

- Keeping your model occupied will not only lessen her anxiety, but also will give your client more variety in her finished photos.

- Your session will run much smoother and faster if you slowly talk your model through action sequences.

- Avoid awkward or uncomfortable poses.

- Watch out for awkward bends in the wrists, and stiff arms and legs.

- Never fold a woman's legs underneath her body as she sits.

- Avoid twisting necks.

- Watch for figure flaws, such as "thunder thighs."

- Do not over-light your subject's hair.

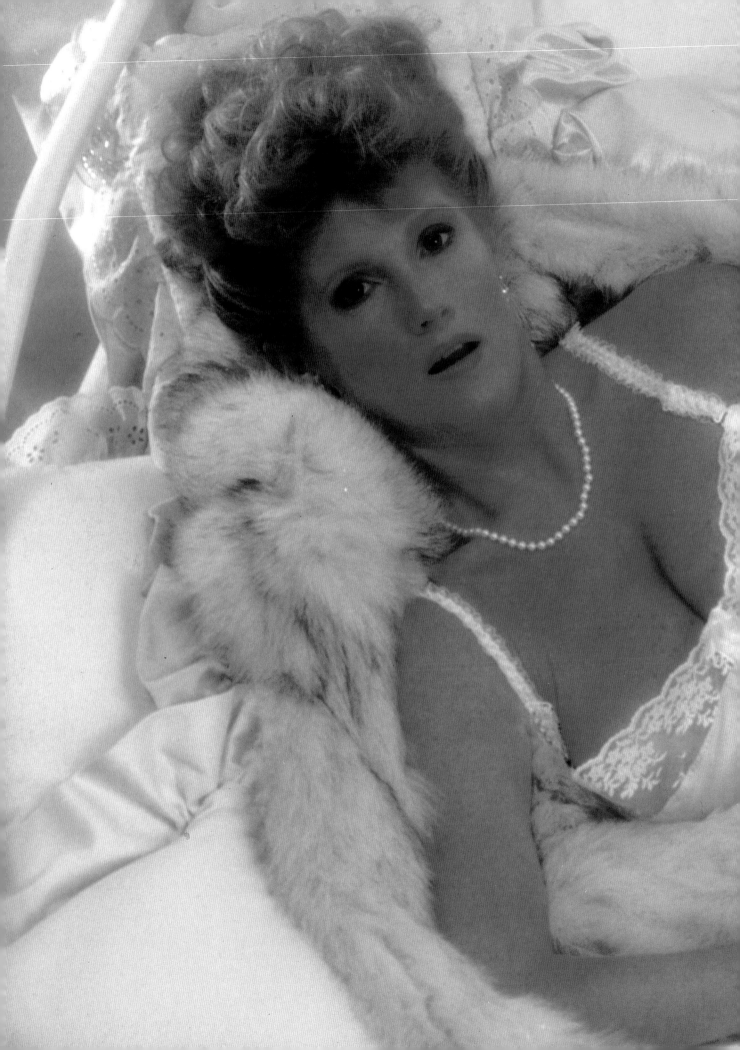

PART FOUR

Creative Approaches

*O*UR CREATIVE conceptualizations are our studio's greatest assets. Execution is important, of course, but without the proper idea for a set or concept, no session is possible. We are often asked about our process of conceptualizing boudoir sets, and we answer that, though we work in many different ways, certain key concepts are always kept in mind. The first is that the model must be the center of attention; the sole function of any set or theme is to surround your model, not to engulf or overpower, but to complement her.

Once a central theme for your model has been chosen, the wardrobe, set, and other variables seem to click into place. Use a theatrical approach to set building. Use creative license. Build partial sets. Give the feeling or impression of a theme by focusing on a couple of elements relating to it. A little wood and some hard work can create a multipurpose set that might later be transformed into three completely different environments. Remember, also, that a shell of a set can be propped differently for variety. Above all, have a specific shot in mind before you even set up your camera gear; think everything through first to avoid random shooting.

Conceptualizing shots is necessary outside the studio, as well. The wonderful thing about location photography is the endless variety it can bring to your creative judgement. Each location has its own particular feel and challenge. When preparing to work on location, pre-scout your location, so that you will have an idea in mind for the lighting you will encounter there, as well as what other elements are on hand to work with. While scouting your location, check for your electricity needs. How much, how many amps, and how many extension cords you will require are all important considerations. What are the primary light sources of the room you will be shooting in? Fluorescent lights? Sunlight? How large a facility or room do you have to work in? How easy or difficult is it to move furniture and other obstacles? Are the surroundings attractive? Will it be possible to achieve the same color temperature for all of your light sources? After examining the location, you might want to take some detailed notes and make a lighting diagram, information that will become helpful to you when you light the actual shoot. Be sure to ask yourself, "Is there a comfortable area for the model to change and prepare?" Expect the unexpected, and pack accordingly. Many photographers run successful boudoir businesses by shooting entirely on location.

When conceptualizing your shots, remember to vary camera angles. By selecting a high camera angle, you can break the chronic "eye-level" look that can make your work seem dull and routine.

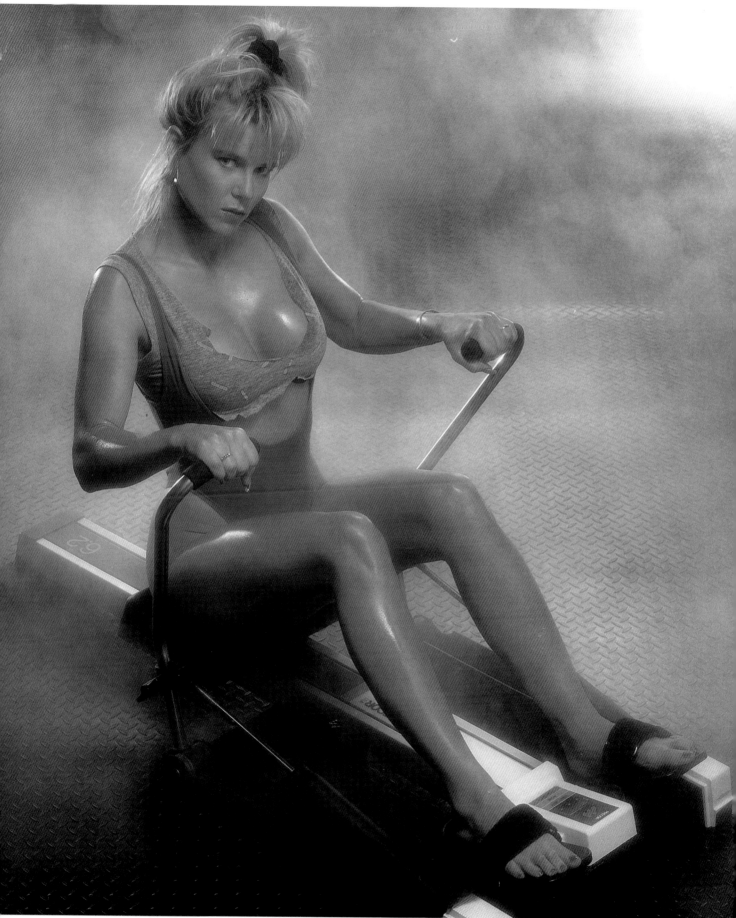

Locker-Room Ideas

Originally when we decided to do a locker-room set, we found out that the price of renting the lockers from a prop house was far too expensive. We almost gave up on the idea, when it dawned on us that we could perhaps find some old lockers from a school. After numerous phone calls, we were referred to a used-school-furniture supply house, and immediately found a bank of lockers that were suitable. We refurbished them with a thorough cleanup and paint job, and they paid for themselves within four boudoir sessions. In this instance, instead of being discouraged when our preliminary idea was not financially prudent, we found a way to make the locker scene work. Remember this when executing your concepts, and explore creative ways to achieve your goals.

You will soon find, as we have, that becoming a good photographer requires you to wear many hats. Not only do you have to be a designer and graphically inclined, you have to be technically proficient, and be able to build and style sets. It is a very physical job; many hours go into the building and preparation of a set alone, from buying wood to finding satin sheets. The experience of creating your sets is not only challenging, but rewarding, as well. We sometimes search for weeks for the right price on everything from a wooden mirror to a brass bed. This is where the nuts and bolts of your ideas become reality, in their execution.

The 1980s trend toward physical fitness and an athletic appearance, along with the availability of athletic wear, has created many opportunities to expand our boudoir photography.

Set Elements

Bank of lockers
Bench, including paint and hardware
Stationary bike
Rowing machine

For athletic clients, a "post-workout" shot on a locker-room set is ideal. This client's slim physique made her a natural for our gym set. The model had both a white and a mint green T-shirt with her, and we decided to that the "classic" white shirt worked better: it picked up the color of the hand barbell.

114

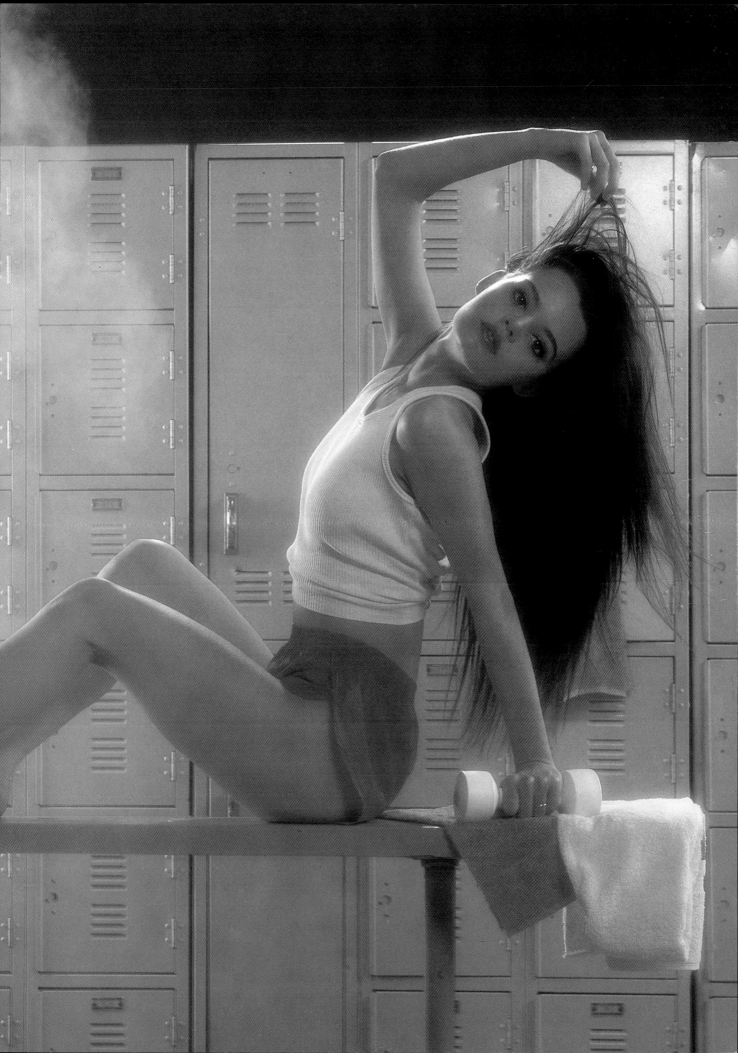

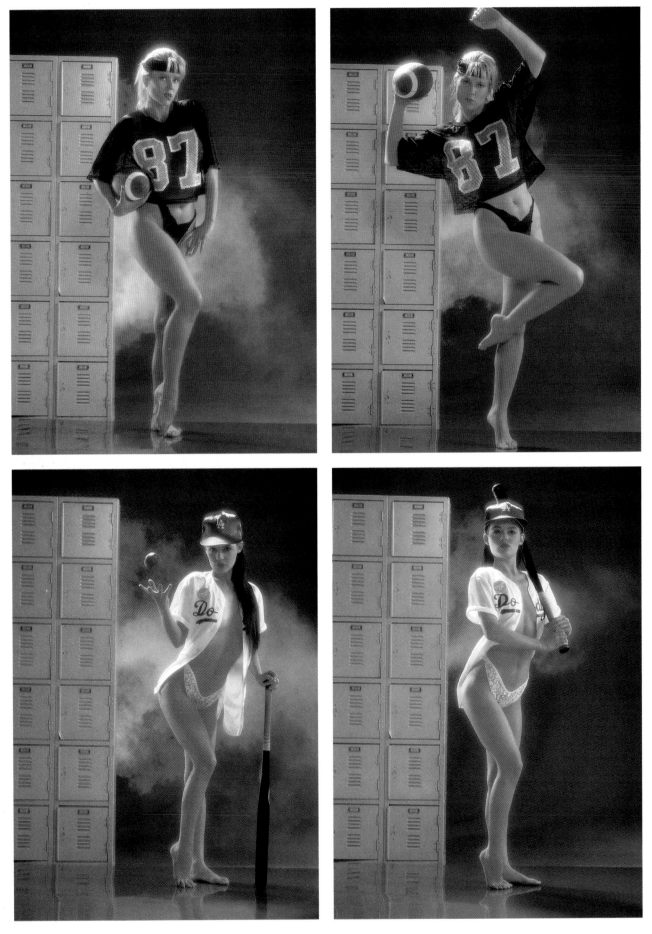

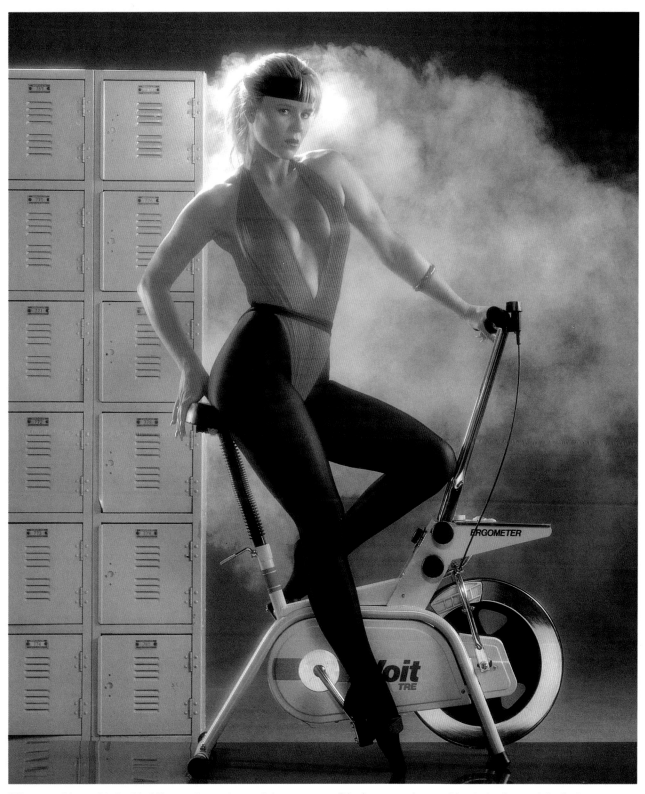

When working with "athletic" sets, have the models actually go through the motions of the sport, such as throwing, tossing, jumping, or batting, like the clients on the opposite page.

Placing a stationary bicycle in front of the lockers on our gym set (above) gives athletically inclined models another posing option.

The Classic Bathtub

It is amazing what wonderfully versatile sets you can create with a little imagination and some wood. We love working with this wooden set, which can take on the characteristics of everything from a Victorian attic to a woodsy cabin. With the addition of a few hay bales and a pitchfork, the same set can be completely converted into a barn environment. We often have our clients model in front of the bath, with the window light creating a warm, sunny mood.

Many women love romantic, old-fashioned looks. One of the most romantic sets we own has to be our claw-footed bathtub. Bubble baths cannot be matched for "clean" sex appeal. Another wonderful quality about the tub is the way it solves figure flaws. Many women who have had children—and some who are pregnant—want a sexy shot that conceals a good deal of their figure.

Not only is this set versatile and alluring, it's fun. You will find that many clients become coy and playful while working within the bathtub set. If, when you suggest that a client shoot in the bathtub set, her first response seems to be disappointment, it's probably because she wants to show off some sexy lingerie or outfit. The beauty of this set is that you can have it all! As you can see, you can start the session with your client doing a slow striptease; then continue the shoot by placing her in the bathtub itself.

We suggest that you do not fill the bathtub completely with water, but, rather, place a tub of bubbles in a large bowl in front of the model. Unless you are actually shooting the effect of a model underwater, and have an unlimited amount of warm water, you will soon learn that a tub of warm water will not only "prune" her skin, but that the water will cool before you're finished with the photo session.

As a photographer you can exercise tremendous amounts of creative freedom. We can change our bathtub set, for instance, as often as we can paint or change wallpaper. By placing the bathtub in a different environment, you can completely change the look of this very same tub.

Set Elements

Claw-footed bathtub
Wood to build set
Window
Cedar chest
Night table
Floor mat
Hand props
Wagon wheel
Rocking chair
Pot belly stove
Wooden barrel

When the session began, we asked this client to pose as if she were undressing slowly before stepping into the bathtub. To create an authentic atmosphere on this set, we placed a small strobe head with an orange gel on it inside the wood stove. We also turned the Galaxy-Ramp way down so that it would provide only a very soft fill light, with no shadows.

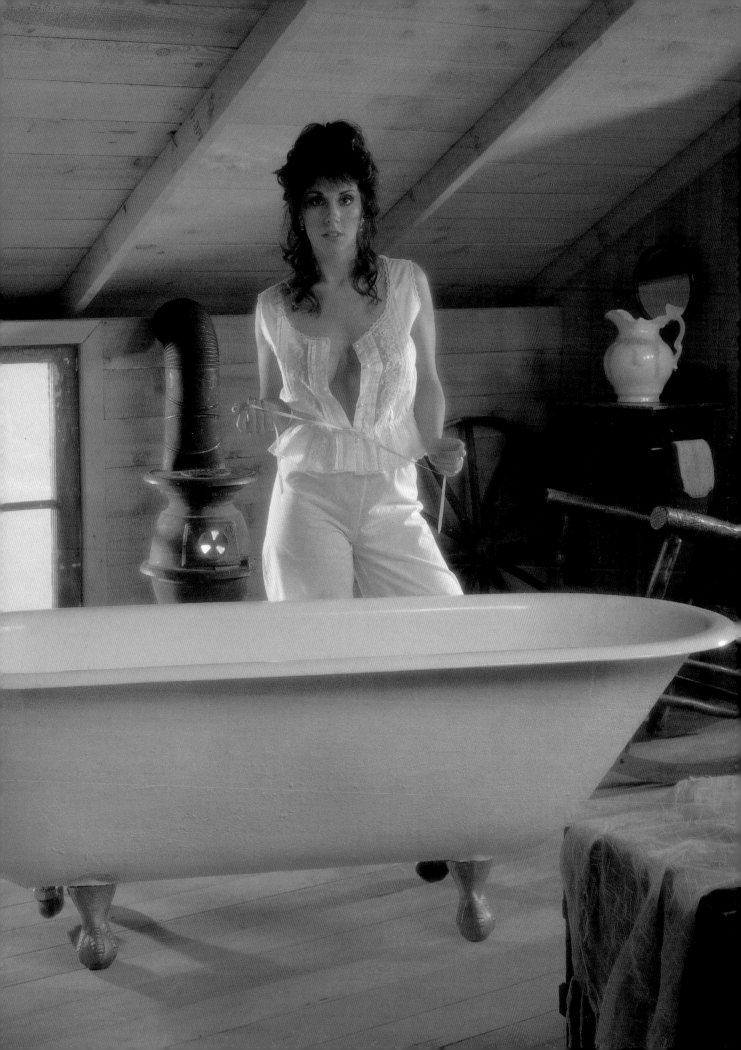

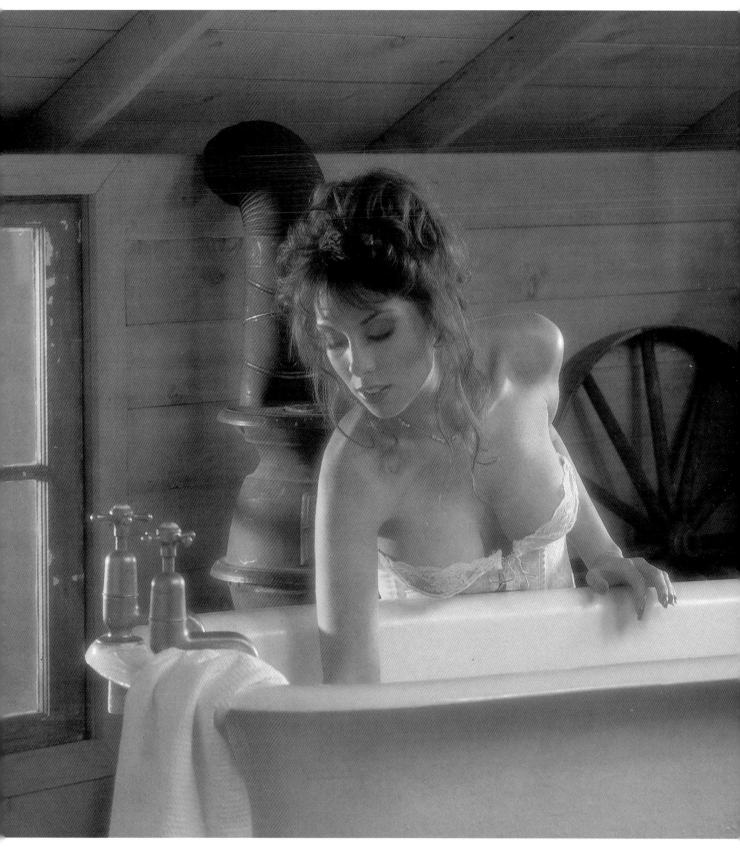

The warm light coming through the window enhances the romantic quality of this photograph, as does the model's old-fashioned corset.

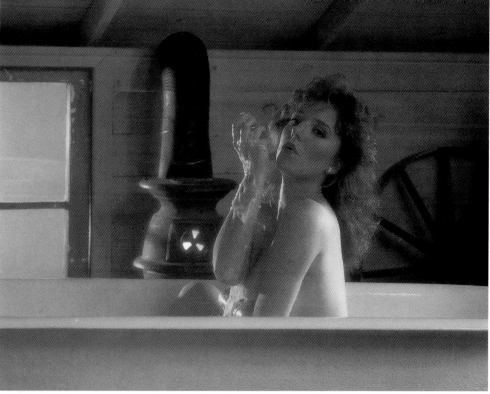

Many models find our bathtub set quite romantic and are able to relax while posing for these shots, which usually look spectacular as a result.

A Barnyard Frolic

As you can see, we have taken the shell of the bathtub set and converted it into a perfect barn setting. (Notice how we have changed camera angles and lighting.) With diffusion the hay bales really become lovely, textured, and soft. This set is perfect for women who want a "country" look. Many of our clients have horses, and they especially love this set.

With the same set but different propping the barn can change from a polo theme to a western theme. Costuming also makes this dramatic difference within the same environment. We love to play with the lighting to create different times of the day. With this particular set-up, either moonlight or sunlight works well.

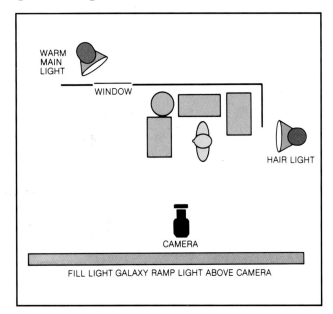

Set Elements

Hay bale
Old wagon wheel
Window
Wooden barrel
Floor mat

The famous Jane Russell pose was the primary inspiration for this barnyard set. The appeal of this photograph is enhanced by the warm golden lighting.

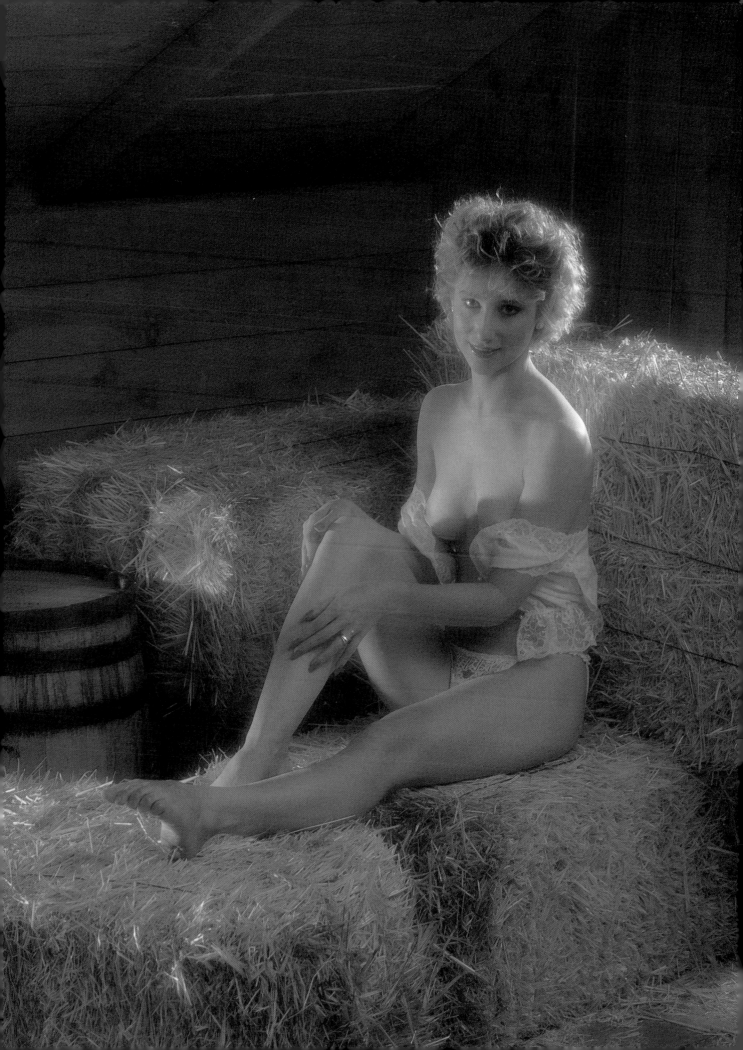

Ice-Cream Dreams

Maximizing opportunity is another very important guideline to successful photography. Keeping your eyes and ears open can separate you from the ordinary. As an example, our opportunity came knocking when we learned that our neighbor owned a fully restored jukebox. It was a wonderful chance for us to shoot with a rare piece. In exchange for photos of his Wurlitzer, our neighbor gladly allowed us to borrow the machine. We then began to piece together our set after finding some wire ice-cream parlor chairs and a table. We also purchased some inexpensive black-and-white tiles at a local flooring store to create purposely the feeling of a partial stage set reminiscent of an old-fashioned ice-cream parlor.

It would have been too costly to completely tile the floor and build a realistic environment, so we turned to the more theatrical approach. A false wall was placed behind the set to add background dimension and give us the illusion of a room. The clock was mounted onto the wall and the Wurlitzer positioned in place. The fully functioning jukebox was a delight to listen to and our subject thoroughly enjoyed her shoot, ice cream and all. Check the detailed lighting diagram to learn how we dealt with the exposure of the neon emitted by the clock and the Wurlitzer.

Set Elements

Black-and-white tiles for flooring
Soda fountain table and chairs
Cushions for chairs
Table accessories

Note: the Wurlitzer and Neon clock were on loan from Hanmar Corporation in Glendale, California.

Although the neon lights in both the clock and the Wurlitzer resulted in a tricky exposure, we enjoyed this photography session as much as our client did.

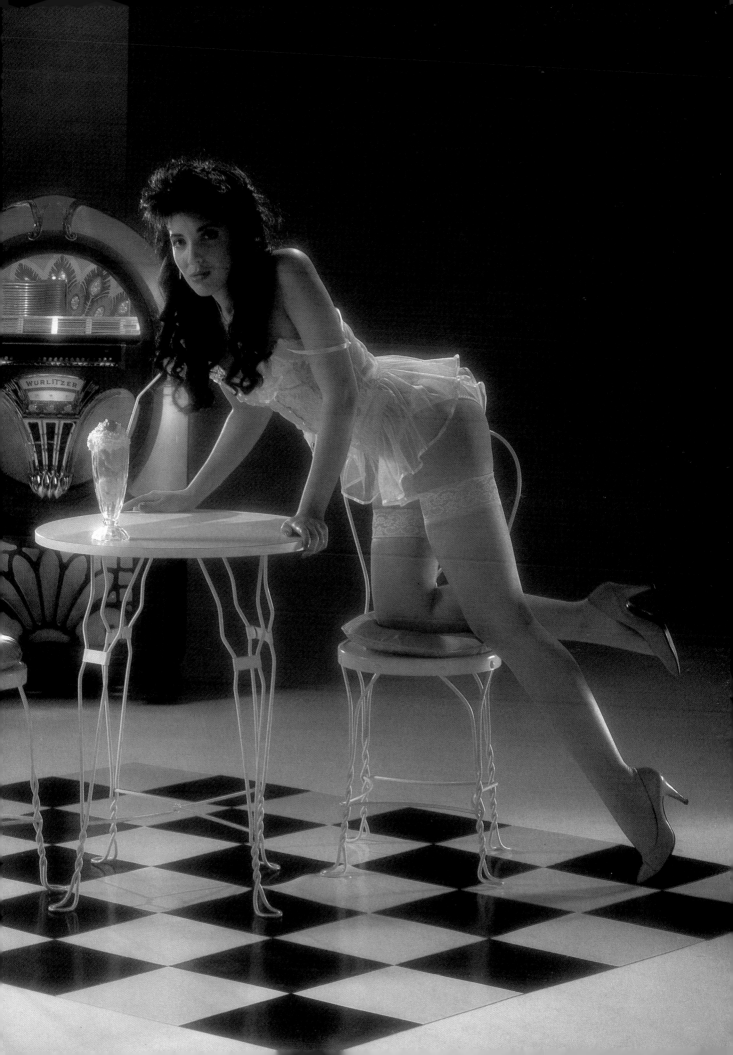

Ice-Cream Dreams

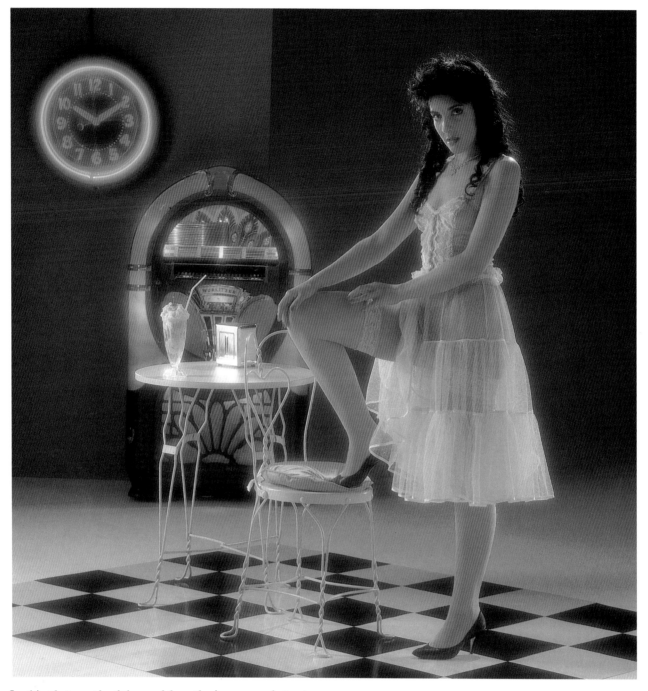

*In this photograph of the model on the ice-cream shop set,
the different hairstyle, outfit, pose, and camera angle
make our client seem sultry.*

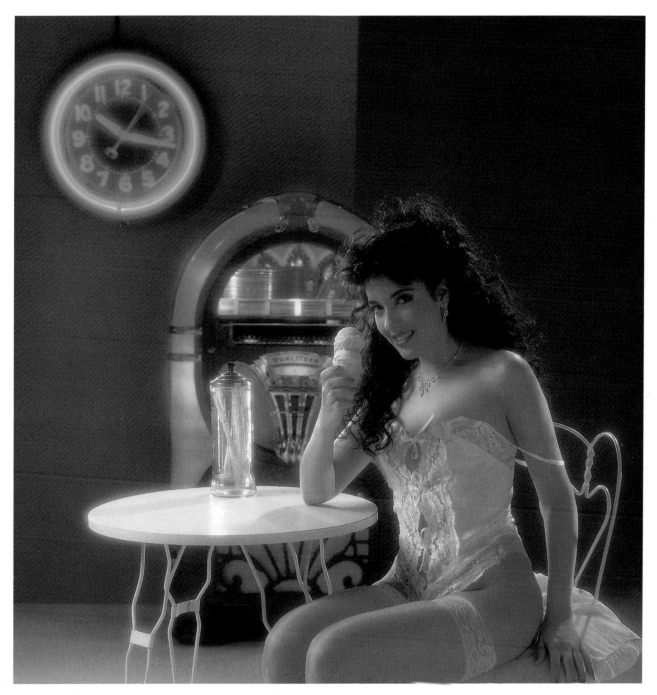

Through the use of a few key props, such as this ice cream cone, old-fashioned straw holder, and neon clock, a set can complete the desired illusion, making it seem quite realistic.

A Special Valentine

It is especially fun and profitable when you prepare to offer clientele something appropriately designed to fit a particular holiday. If there was ever a holiday made to order for boudoir portraiture, it would have to be Valentine's Day, one of the most popular days in the year for us. In this instance, red satin sheets became our focus. The heart pillow accentuated the set and, as you can see, these simple elements make a marvelous Valentine's theme. Feel free to play with other colors on your model. Pink or even lavender can translate into charming Valentine colors. Of course, you can never go wrong with red.

Red satin sheets are a classic set for Valentine's Day; with the addition of a mask and a switch of camera angles, we managed to give this client a more festive and unusual portrait. By playing up the client's well-endowed figure, we made this shot instantly sexy. The life-sized Valentine's card idea came to us as we passed a nearby florist. In the window was a giant heart surrounded by teddy bears and balloons. By simply cutting our seamless around the heart and placing our subject and balloons behind it, our "card" was complete. A diffusion screen was placed behind the balloons and light was pumped through the balloons to create this airy effect.

Set Elements

Red satin sheets
Heart-shaped pillows
Red and white balloons
Masks

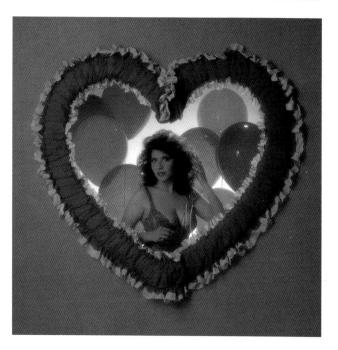

These Valentine's Day portraits create different illusions. The model directly above appears sweet and playful—a look that suits the frilly heart that frames her—while the client at the top of the page seems sultry and seductive. The model opposite looks pleasantly alluring.

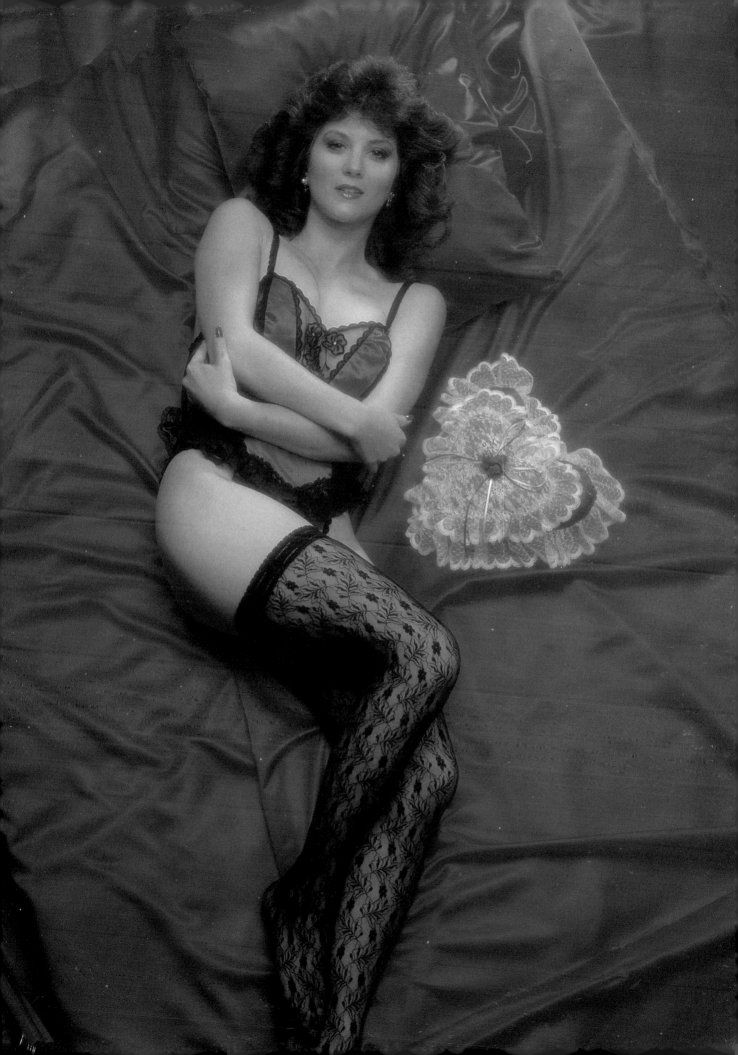

The Fireplace

There is nothing more classical and elegant than shooting a model in front of a stately fireplace and hearth, the perfect environment for a boudoir portrait. The fire, itself, adds warmth and another light source for the photographer.

With this fireplace shot, we wanted to take advantage of shooting the whole hearth and displaying a nice chessboard with our model. After trying various poses we found that standing the model up worked the best. This pose slimmed the model's legs and allowed us to place a nice side light to emphasize her figure. We cleared the area of knickknacks and clutter, and we were on our way.

There will be many on-the-spot decisions to make during a location shoot, when everything from exact wardrobe to the color of the client's lipstick can change from your previous plans. When you are actually working with your client you must be flexible and prepared for these decisions.

People often feel that location work is easier than working in a studio, and that a photographer would tend to use less equipment. This is a great misconception. When you work within the confines of a well-equipped studio, you have total control of your lighting, while on location you must deal with the many different light sources. We take even *more* equipment on location than we use in our studio. You may not always need everything that you pack on location, but you are better safe than sorry. So we do overpack, because the time you do not pack a particular piece of equipment is when you will need it!

Set Elements

Fireplace
Chess set
Pillows

For this fireplace picture, we wanted to include the entire hearth and the chessboard to create a cozy feeling. After trying various poses, we found that having the model stand up made her look her most attractive. This pose slimmed her legs and allowed us to emphasize her figure with sidelighting.

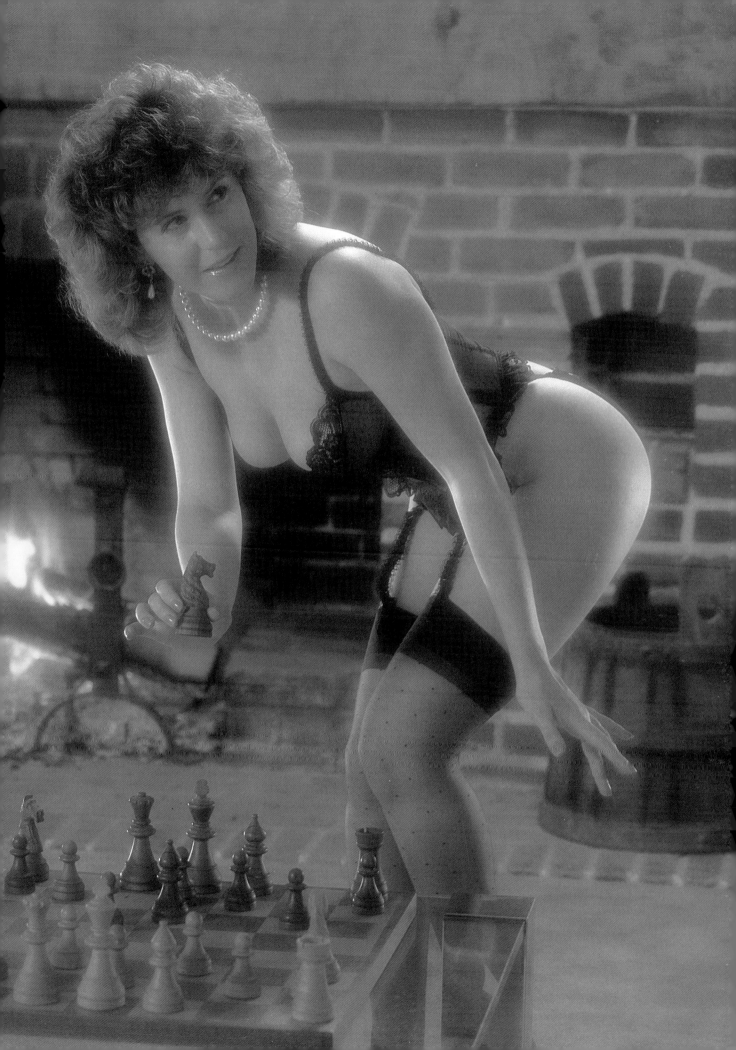

Outdoor Locations

Shooting an outdoor location has its own special challenges and rewards. Some locations lend themselves to our type of photography better than others. At the top of our list of favorites are tropical settings. Whether you are in Mexico, a garden isle in the Hawaiian Islands, or your own backyard, you can create lush green tropical looks for your model. Remember, though, never to let the grandeur of the location upstage your subject.

There are all types of approaches a photographer can take when doing outdoor photography. The approach we take is similar to the one we take in the studio: we use our studio strobes to augment the natural light. Both examples from our tropical shoot had sunlight augmented by two strobes. In the shower shot opposite the sun was almost overhead and behind the model. The warm light coming through the shower was created by a strobe head with a warm color gel over it coming from behind the model to camera left. A second strobe head with a PLB was positioned to camera left. The purpose of this light was primarily to define the model's form and to boost the shadow detail. There is a careful balance that must be achieved in using this light. If there is not enough output, your subject is underexposed; too much and you have that cut-out-and-pasted-down-too-much-flash-fill look.

The exotic tropical session (shown on page 134) was shot in the same proximity as the shower photo. This time the natural sunlight is filtered through vegetation and is striking our model from camera left. The warm back light is a strobe head directly behind the subject with a warming gel to create the tropical look. Here, the fill light was a PLB positioned horizontally over the camera.

Obviously, an available electrical source or a generator is extremely useful in situations like this. Reflectors could also be used in this situation but they are much more awkward to handle, require a bigger crew to use, and are almost impossible to manage in the slightest wind. Even a breeze can send you and your crew scrambling in all directions to recover sailing reflectors.

On outdoor shoots, depending on the time of day, we usually use the sun behind our subject, if at all possible. With the sun behind the model a natural back light look can be achieved and deep shadows under eyes and nose are kept to a minimum. Frequently we will augment this light with a strobe as well as warm gels positioned to back light the subject. On a typical sunny day we use a Balcar PLB on another strobe near the camera, to boost the shadow side and give detail without overpowering the natural light. When trying to achieve this delicate balance, an ambient light meter is especially important, so you can monitor the changes in sunlight. We also frequently shoot in open shade, which creates a very flattering beauty light. A warming filter such as an 81A or 81C is especially useful in overcoming the cool color temperature of the light.

We often augment an outdoor shoot by placing potted plants among the resident foliage, just as we surrounded our model with plants in our indoor pond shot. We often bring assorted ficus trees and palms to a backyard shoot.

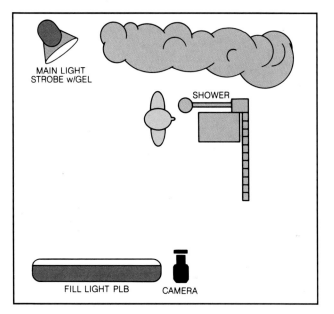

By placing some foliage toward the front of this scene, we were able to add depth and dimension to the photographs.

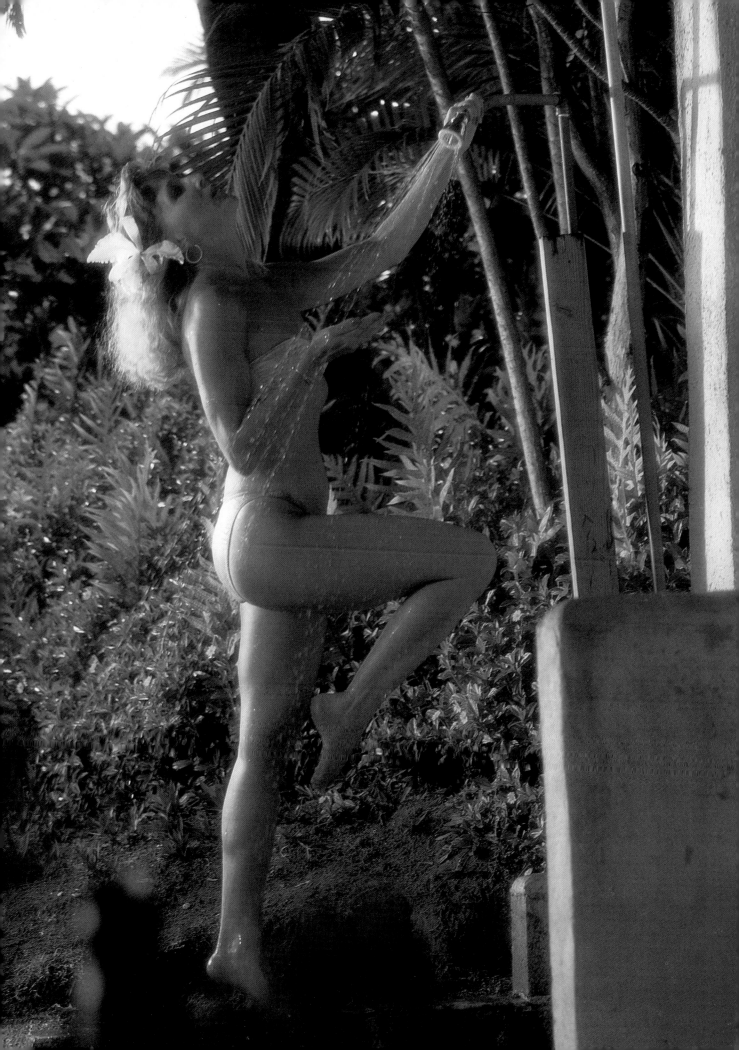

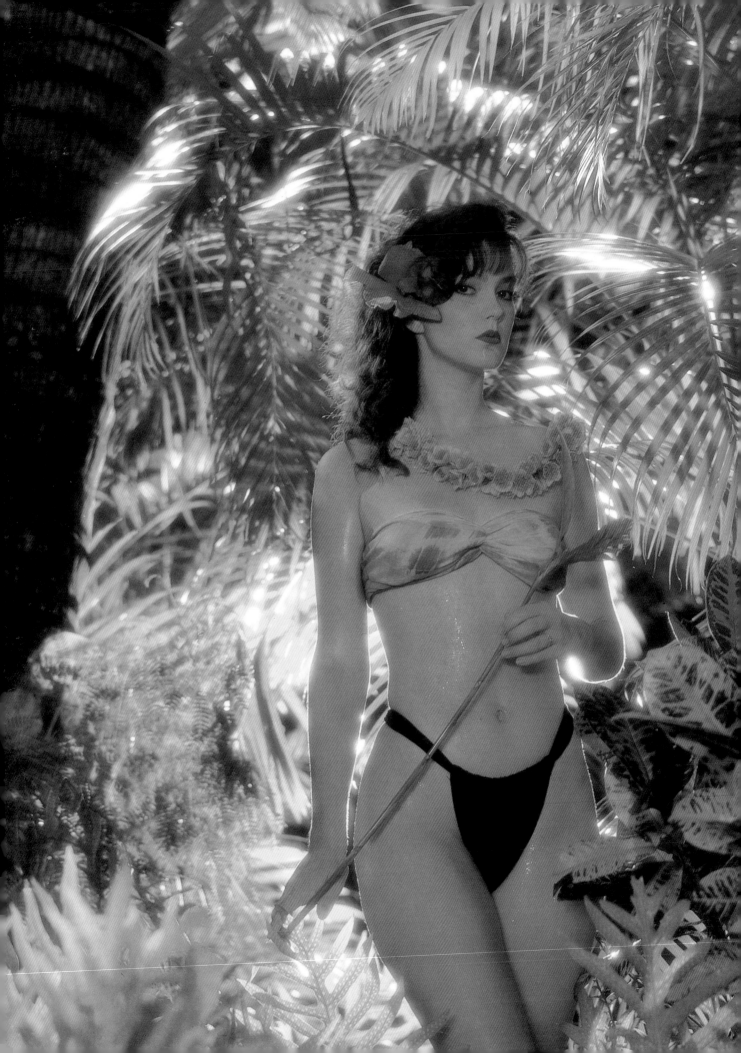

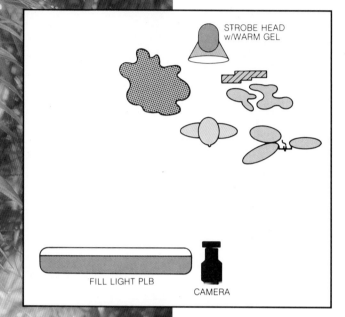

The yellow filters that were placed over the light source directly behind the model create the illusion of warm sunlight falling on her.

On-Location Packing List

The following is a partial list of recommended gear for location photography:

- **Hasselblad EL camera** (motor-driven Hasselblad)

- **Hasselblad 500C** (manual Hasselblad)

- **Case w/**
 Charger
 Polaroid Back
 50mm
 80mm
 150mm
 Accessories including lens cleaner, P. C. cords, cable releases

- **Exposure Meters**
 Flash meter
 Ambient light meter
 Spot meter
 Spare batteries

- **Filters**
 C C filters
 Diffusion
 Fog

- **Lighting**
 5000 w/s Balcar strobe unit
 2400 w/s Balcar strobe unit
 6 flash heads
 Power and extension cords
 Spare fuses

- **Grip gear**
 Tripod
 4 Century light stands
 2 booms
 6 light stands and low stands
 Sand bags
 Selection of tape
 Reflectors
 Generator

- **Film/Polaroid**
 Color transparency film
 Color negative film
 Black-and-white film

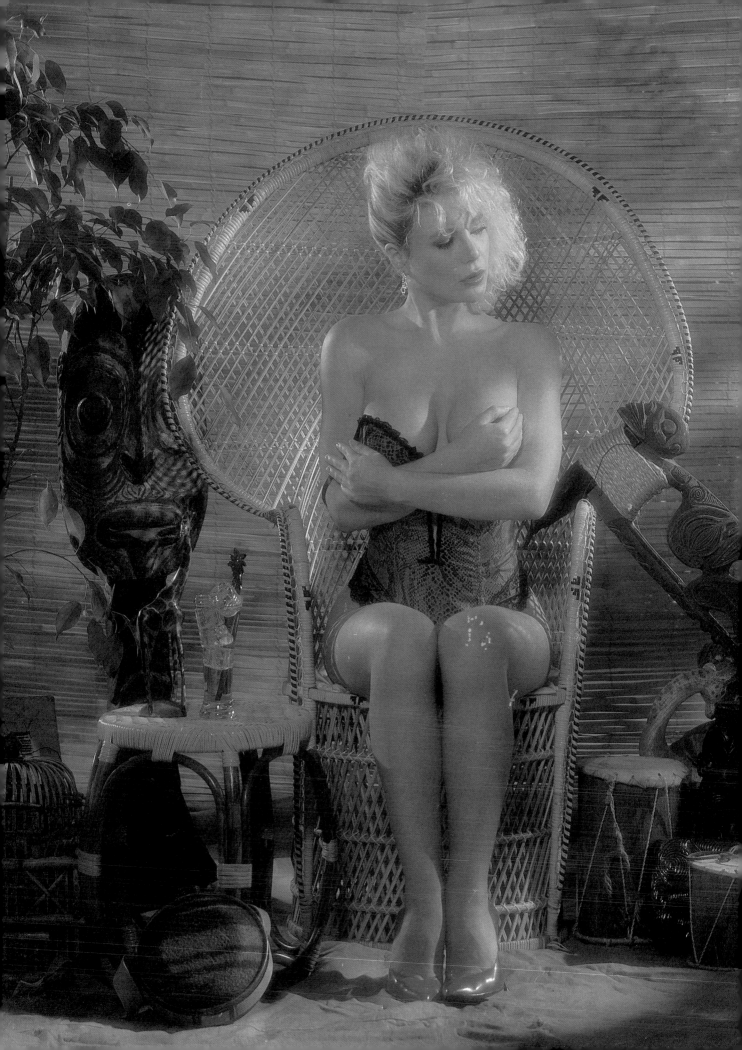

The Heat of the Jungle

Some of the most fun we have with photography is in creating illusions of exotic environments within the confines of our studio. With a little imagination and work we can transport our model from a Victorian bedroom to a wild jungle. What makes our set believable is the feeling of heat created by the lighting.

Creating jungle shots can be simple. We started off with a bamboo backdrop, and used two overlapping bamboo shades to give us enough width. A peacock chair became our main prop. This environment allowed us to work with the model as she related to the chair in various poses. We then placed various African theme objects all around the set. A cool tropical drink enhanced the illusion of a "hot" environment; the most important touches came with the lighting of our set and the model's wardrobe and attitude. Her lovely teddy worked quite well. The animal print on red fabric made it look even better. The deep red saturation related well to the set and to the "hot" environment, and was just the amount of rich, vivid color that draws the viewer's attention to the subject.

Set Elements

Bamboo background
Peacock chair
Assorted tiki torches
Spears
Feathers
Drums
"Idols"

The peacock chair on our tropical set allowed this model to pose naturally and comfortably.

With our jungle theme we can incorporate details, such as a tropical hut and a pond. As you can tell with our jungle-pond set, we have created a feeling of being outdoors, with sunlight reflecting on the water, while plants, rocks, and orchids surround our model. These are the details that make this environment seem real.

With a set such as this, your subject should bring several swimsuits with her. Our client brought a solid black suit that we chose not to use, because we lost her figure in the background. We consciously kept the model's hair dry in the beginning of the shoot, but, as she began to feel more relaxed, we instructed her to begin to wet her hair.

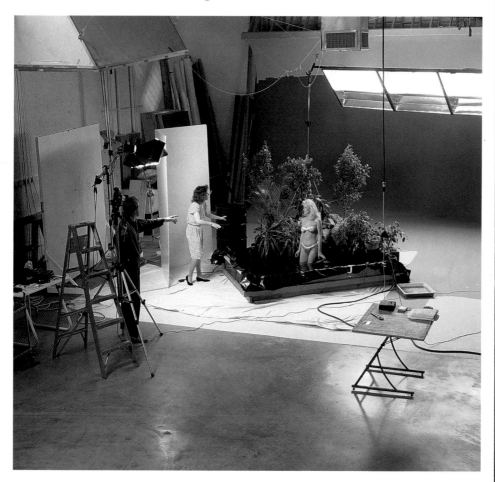

Set Elements

Shower head and piping

Wood for pond and hardware bracing

Plants for tropical sets

Fog machine and chemical fog or dry ice

Lining for pond set

Our jungle set is an unusual yet appealing background for boudoir portraits. Although this client was a bit tentative at first, she was able to relax as we offered specific suggestions and reassurances. The session was a success, as is this photograph.

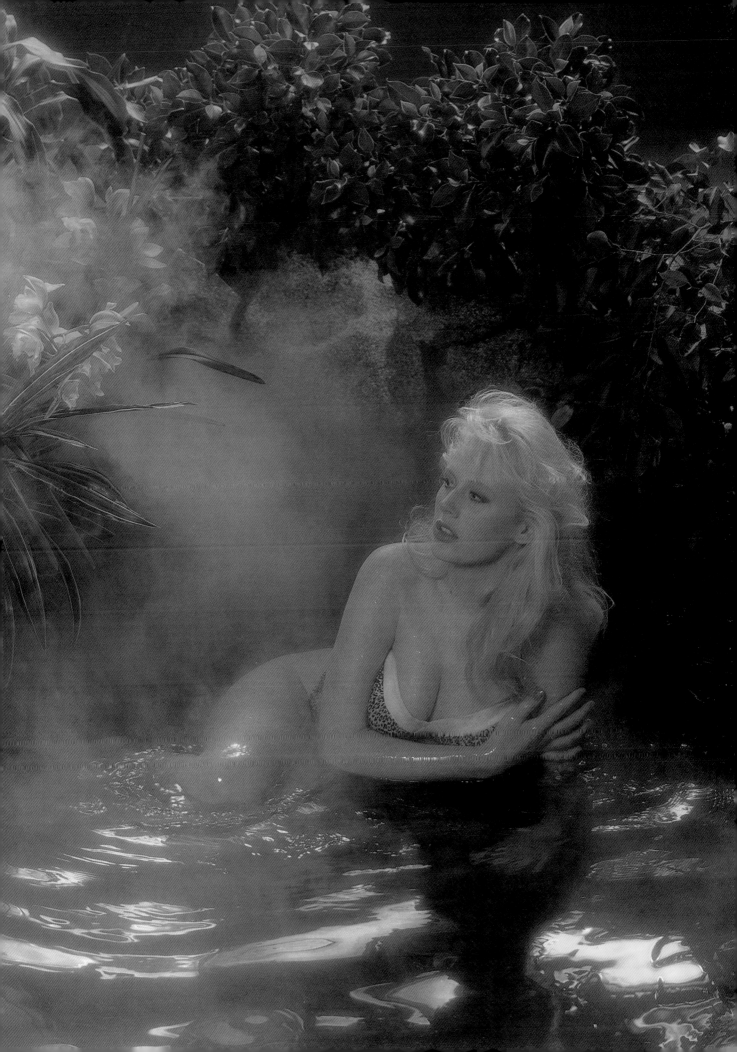

Crazy about Cars

It has been said that a man's second love, next to women, is his car. Many men take painstaking care of their automobiles. Automotive shots with women often adorn posters, and many clients inquire about being photographed with a car.

Fortunately, we have done automotive photography and have a large studio and cove to facilitate shooting a car on the set.

Our first priority is to make sure that any car we shoot is spotless. A good wax job is also mandatory. The car does not necessarily have to be new, but good conditioning will enhance the shot. Clean tires and wheels are also important to the shoot. You may want to take along a cleaning kit, for insurance.

Tear sheets are very helpful when designing a car shoot. Happily, there is an abundance of source material, so do your homework! Whether you are shooting this job on location or in the studio, you must know what angle and look you want to achieve before you begin working.

If the shot is a direct profile of the car with a low camera angle, the wheels should be as straight as possible. If the nose of the car is facing the camera, you may want to add drama by turning the wheels a bit. You will often have to mask all the mirrors on the car to minimize reflections. For a beautiful professional touch, try leaving the headlights turned on; this will necessitate shooting with the model lights very low and a time exposure.

Shooting with an automobile usually requires a large light source. What better light source is there than the sun? The key to shooting automotive scenes on location is to control the light. Now you can't necessarily control the value and quality of sunlight, but you have to control as many variables of the shoot as possible. For example, you will want large silks or screens to diffuse the light. The best time to shoot automotive shots on location is either at sunrise or just before sunset. You will find that shooting at this time of the day will substantially increase the drama you can obtain in your shot.

When scouting for the perfect location, keep in mind that the most attractive areas have simple backgrounds. Another professional beautifying trick is to wet the pavement down with water before you shoot; you can achieve stunning lighting and reflections through this simple step. Be prepared far in advance of the approaching sunrise or sunset. You will learn that the "perfect" time for automotive photography will last only a few minutes. Take your Polaroids and be prepared just before your anticipated lighting. Then start your session a few minutes before your prime lighting arrives. Shoot as the prime light approaches and then continue to shoot a few minutes after your prime light has passed. The richest color saturation occurs before prime light during the morning, and right after prime light at sunset.

Automotive shooting within the studio is much more complex than it is on location. Again, a broad light source is a must. If you have had any experience in lighting a shiny object, you will understand that everything on the set will be reflected from your car. Do not attempt this type of studio photography too soon in your boudoir career. A properly lighted and executed car shot requires considerable expertise, space, and equipment.

Set Elements

High tech flooring
White painted background

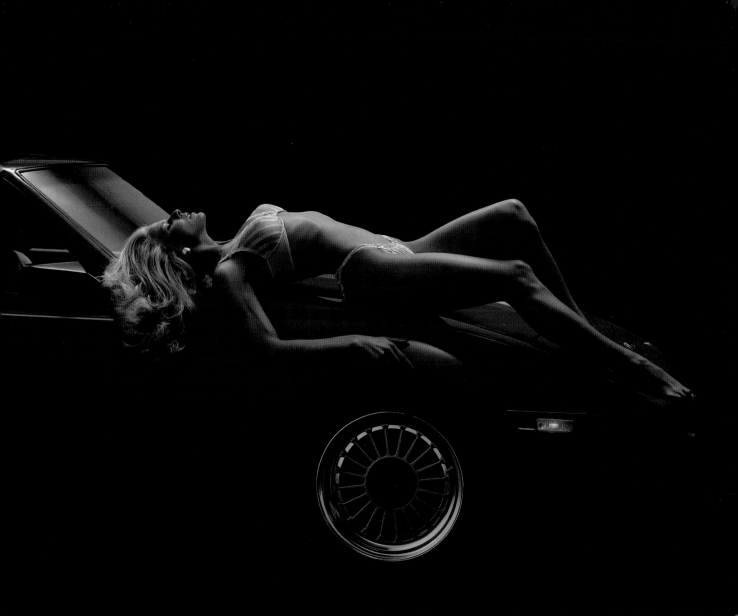

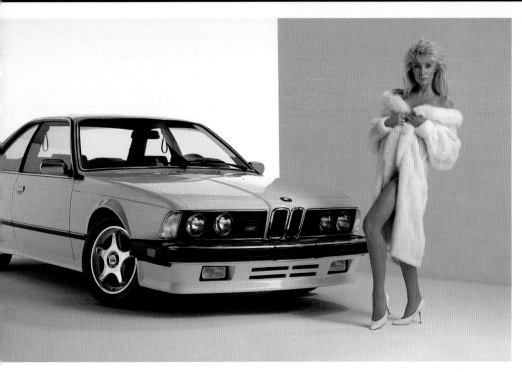

For the shot above, we draped the model across the hood of a red sports car. Her languid position, along with her ivory lingerie and thick, blonde hair resulted in a sensational portrait.

To create a clean, stark look for this model, we chose a white color theme. The resulting image, complete with a fur and a luxury car, is elegant and stylish. Portraits like this are sure to please any car fancier.

By having the model arch her back, we were able to separate her slim waistline from the hood of the car in this semisilhouette.

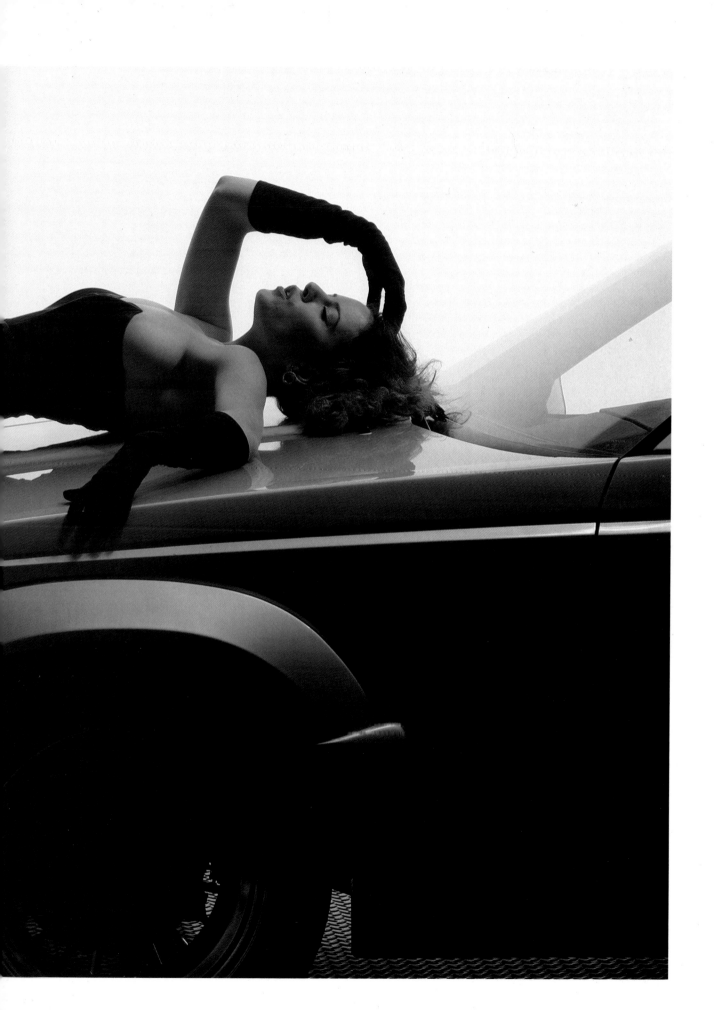

Index